KLEE WYCK

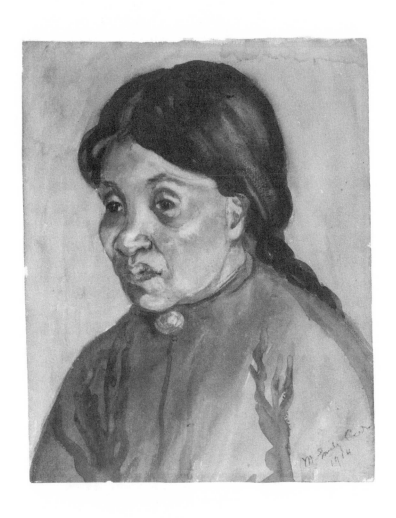

EMILY CARR

KLEE WYCK

FOREWORDS BY IRA DILWORTH
INTRODUCTION BY KATHRYN BRIDGE

Douglas & McIntyre

VANCOUVER / TORONTO / BERKELEY

Douglas & McIntyre Ltd.
2323 Quebec Street, Suite 201
Vancouver, British Columbia
Canada V5T 4S7
www.douglas-mcintyre.com

LIBRARY AND ARCHIVES CANADA CATALOGUING IN PUBLICATION
Carr, Emily, 1871–1945
Klee Wyck / by Emily Carr ; foreword by Ira Dilworth ;
introduction by Kathryn Bridge.

ISBN-10: 1-55365-027-1 (bound) · ISBN-13: 978-1-55365-027-0 (bound)
ISBN-10: 1-55365-025-5 (pbk.) · ISBN-13: 978-1-55365-025-6 (pbk.)

1. Carr, Emily, 1871–1945. 2. Painters—Canada—Biography.
3. Indians of North America—British Columbia. I. Title.
PS8505.A764Z53 2003 971.1′00497 C2003-911184-9
Library of Congress information is available upon request
Editing by Saeko Usukawa
Design by Ingrid Paulson
Printed and bound in Canada by Friesens
Printed on acid-free paper

Distributed in the U.S. by Publishers Group West

We gratefully acknowledge the financial support of the
Canada Council for the Arts, the British Columbia Arts Council,
and the Government of Canada through the Book Publishing Industry
Development Program (BPIDP) for our publishing activities.

Frontispiece: *Portrait of Sophie* by Emily Carr, courtesy of Jane Williams

To Sophie

❧ CONTENTS ❧

❧ INTRODUCTION: THE LOST *KLEE WYCK* ❧
by Kathryn Bridge

IN NOVEMBER 1941, artist Emily Carr made her debut as a writer with the publication of *Klee Wyck*. The powerful simplicity and vividness of this collection of twenty-one short stories and word sketches won it instant critical acclaim and made it a best seller. The following year, the book won the Governor General's Award for Non-fiction, Canada's highest literary honour. Since then, *Klee Wyck* has been in print continuously; but how many readers are aware that the *Klee Wyck* that has become a classic is not the *Klee Wyck* that was originally published?

In the course of my work as an archivist at the British Columbia Archives, which holds the Emily Carr papers, I have had the privilege of viewing the rough drafts and preliminary versions for many of the stories later published in her several books. These literary manuscripts, with their editing marks and comments, cross outs, inserts and modifications, allow us to see how Carr crafted her writing as she reworked and polished the text into its final form. She deliberated over words and pared sentences to their essence. As she later remarked, "I did not know book rules. I made two for myself. They were about the same as

the principles I use in painting — get to the point as directly as you can; never use a big word if a little one will do."[1]

Knowing all this, I was taken aback when, at the suggestion of Dr. Gerta Moray, a scholar who was then undertaking an intense examination of Carr's early "Indian paintings," I undertook a close comparison of the current paperback version and the original first edition. It was then that I learned that Carr's final product—the words and sentences she had honed and polished and published in *Klee Wyck*—were, a few years after her death in 1945, expurgated by a new publisher, who did not inform the reading public of this action.[2]

Several generations of Canadians who have read and enjoyed a volume of *Klee Wyck* printed after 1950 have missed out on the full, original text. It is only now, with this publication, that Carr's original *Klee Wyck* text—in its entirety—can be read once more.[3] This volume also restores Ira Dilworth's original 1941 foreword, and the complete version of his second foreword written a decade later.[4] Together, they provide biographical information about Emily Carr and her motivation for writing, analyse her creative process, and discuss her style and her use of language.

But before looking at how *Klee Wyck* came to be expurgated, it is important to appreciate the chronology of events prior to its publication and also the reception *Klee Wyck* and its author received upon its release.

The time leading up to the public unveiling of *Klee Wyck* were transition years for the elderly Carr, who was born in 1871. Failing health—angina, followed by a series of heart attacks beginning in 1937—made travel difficult and reduced her physical capabilities. She was no longer strong enough to embark on sketching trips or even to cope with many of the daily chores revolving around her

house and animals. Trapped indoors recuperating, Carr stayed abed most mornings and one full day each week.[5] Forbidden by her doctor to paint, time weighed heavily on this woman, who was normally so vital and focussed, so she pulled out her old journals and drafts of stories written a decade earlier and used these as the basis for a new batch of short sketches. She transferred her energy into re-creating past adventures, recording her impressions of the Native people she had met in the villages and reserves decades ago. Her aim was to bring life and dignity to these people, to give them individuality and voice. She also wanted to show, through her writings, the harm she saw inflicted on First Nations people by the settler society that sought to assimilate them into mainstream culture and whose racist views not only blinded them to the values of aboriginal culture but reinforced their assumption that these people were a dying race.

Within months, Carr had completed first drafts of most of the stories that would form *Klee Wyck,* along with other stories recounting experiences from her childhood.[6] Through her "listening ladies"—a small group of women friends whom Carr trusted and respected, and who gave her feedback on the drafts and helped with the typing—she submitted selections of stories to various magazines and publishing houses, including both Macmillan of Canada and Ryerson Press.[7] But it was not until one of her "listening ladies," Ruth Humphrey, passed them on to Ira Dilworth, a former professor of English at the University of British Columbia and then the regional director of the Canadian Broadcasting Corporation (CBC) in Vancouver, that any progress was made. Dilworth had local connections to Carr that helped break the ice. As a teenager, he had lived in the same neighbourhood, and he recalled Carr and, of course, her entourage of animals.

Dilworth was a busy man, but once he read her stories, he became a sincere supporter and used his broadcasting connections to promote Carr's writing. In January and February 1940, Garnett Sedgewick, another Carr advocate, read several of her stories over the local CBC radio station, and in later years Dilworth read other stories aloud on national CBC radio broadcasts. It was an ideal way to introduce a new author to Canadians across the country.

A few months after the first broadcasts, on a visit to Toronto, Dilworth left a sample selection of Carr's stories at the editorial offices of Oxford University Press. Faced with Dilworth's persistence, manager William H. Clarke ultimately agreed to publish them, a significant commitment in wartime. An insecure yet ecstatic Carr, scarcely believing the good news was real, kept it a secret and steeled herself against the possibility it would come to naught.

In late March 1941, Clarke and his wife, Irene, travelled to Victoria to meet Carr, and it was only then that the deal was made. Carr wrote to her friend Nan Cheney, tempering her excitement with pessimistic comment that reflected upon the potential for disruption by war. "Well, it is *really going* through. The Oxford University Press is bringing out a book of me, about xmas if we are not bommed [*sic*] off the earth first."[8] A contract followed in May and, by June, she had sent the stories to her publisher. In September, the title *Klee Wyck* was decided upon over Carr's initial title, "Stories in Cedar," and the illustrations and dust jacket images selected.

Finally, in October, she held in her hands an advance copy, minus the dust jacket, which was still being printed. The almost seventy-year-old author, who had fussed and worried through the editorial process, partly disbelieving in its fruition, then

remarked that it was "a real *object* at last even though only in her underwear." Despite the fact that store windows were displaying the finished product, Carr continued to express metaphoric insecurities. "*Klee Wyck* had better put on her corsets & jacket & face the world, pretending to be brave even if she doesn't feel it."[9]

The publication of *Klee Wyck* in November 1941 catapulted Carr into instantaneous acceptance nation-wide. Robertson Davies, writing in *Saturday Night*, described Carr as "an author who is destined to leave a lasting mark in the world" and predicted (with accuracy) that within two years she would "be generally recognized as one of the foremost among the few important writers that Canada has produced."[10]

Emily Carr's writing was praised by critics for the same qualities that made her paintings popular. It was "direct, uncompromising, intensely alive, full of colour and clear in outline."[11] Just as her vibrant oil-on-paper sketches of forests and seas and skies were economical in their fluid brush strokes, her evocative prose was spare and lean. "Completely free of fripperies and self-conscious fine writing, every unnecessary word has been purged from her descriptions, every thought is as clear as a bell."[12]

Shortly after the book's launch, Carr turned seventy, on 13 December 1941, and the Victoria community planned a very special gala organized by the Women's Canadian Club. One hundred invited guests applauded as the master of ceremonies read messages of congratulations from both the lieutenant-governor and premier of British Columbia. Terrified of public speaking, a trembling Carr read from her prepared speech. "Thank you everybody for giving me such a splendid, happy birthday party and for being so kind to *Klee Wyck*. I would rather have the good-will and kind wishes of my home town, the people I have lived

among all my life, than the praise of the whole world." As Carr
later confided in *Growing Pains*, her proudest moment was when
Ira Dilworth, after reading aloud two brief sketches of hers, "gave
her a 'kiss for Canada.'"[13]

The success of *Klee Wyck* was due in part to Carr's appealing
and unaffected descriptive style and her ability to bring life to
characters and the landscape. Writing provided a successful com-
plement to her painting, which had been in the public eye for
some time, but in its content and subject matter, Carr intended
not only to entertain but to enlighten. She had a mission and a
message.

It was an era of contradictions. A paternalistic federal govern-
ment had set up anti-potlatching legislation and other measures
to deprive First Nations of their traditions and culture, and to
assimilate them into the settler society. Yet small non-Native
organizations were springing up to counter the prevailing opinion.
One of these was the B.C. Indian Arts and Welfare Society, which
promoted cross-cultural understanding and awareness, encour-
aging artists to continue and pass on their traditions to the next
generations. And it was provincial government sponsorship that
established Thunderbird Park in Victoria to display totem poles.
At the same time, compulsory education at huge residential
schools forcibly separated Native children from their families
and from their remote communities. At these schools, children
were forbidden to speak their Native languages or follow tradi-
tional ways, and the physical, sexual and psychological abuse
that they suffered had a devastating effect on First Nations society.
Generations lost their language and pride in their heritage, and
were deprived of normal family life. It is a shameful chapter of
the times.

Some of the reviewers of *Klee Wyck,* both in the eastern Canadian press and those in Carr's home province, understood her message. A Vancouver paper noted that *Klee Wyck* "provokes a new interest in an age that is nearly dead and a sharp twinge of conscience that something beautiful and native to this country has been killed by 'progress.'"[14] From one of the bastions of white society, the Imperial Order of the Daughters of Empire (IODE) came high praise. "No intelligent reader will disregard this book" stated their national newsletter. Then followed the courageous statement: the author "finds little to praise in the Christian missionaries who have separated [the First Nations] from their old faiths."[15] Blair Fraser, literary critic for the *Montreal Gazette,* was more direct. "Her rage burns as hot as any Indian's, when she sees their ancient ways forgotten, their ancient arts lost, their inner integrity destroyed by the fatal touch of the white man." He then added, in case there might be some uncertainty: "She has a vitriolic hatred of missionaries."[16]

Launched in time for the Christmas trade and buoyed by critical acclaim, the book's first printing of 2500 copies sold out by year's end. A second printing followed soon in the new year, along with publication in the United States by Farrar & Rinehart. In its review of the American edition, the *New York Times Book Review* was lavish with praise: "She is . . . a natural-born writer. There is a vividness and poignancy as well as spontaneity in the enlightening collection which makes this book. . . . She saw, and catches in a few words, the characteristics and atmosphere of lonely islands and wilderness settlements. And she writes with a brisk and sensitive originality."[17]

That same year, 1942, when *Klee Wyck* won the Governor General's Award, continuing ill health prevented Carr from travelling to accept the award in person. Her publisher received the

medal on her behalf at a ceremony in Montreal and forwarded it to her by registered mail.[18] Upon opening the parcel, Carr gasped at the unimaginative medal design and the truly second-class engraving of her name and book title. "My name & what for are scratched on it with measly gilt letters," she muttered to a friend.[19]

Over the next decade, Oxford University Press responded to the demand for copies of *Klee Wyck* by keeping it in print. The continued popularity of the book prompted William Clarke, who was also the founder and president of Clarke, Irwin and Company, to purchase the rights to *Klee Wyck* from Oxford. In 1951 Clarke approached Ira Dilworth, who had been named as Carr's literary executor after her death in 1945, with a proposal to include *Klee Wyck* in Clarke, Irwin's "Canadian Classics" series of educational publications for schools and a request that Dilworth write a new foreword, one suitable for classroom use, combining "both biographical material and some discussion of Miss Carr's skill in writing and the background of this."[20]

The idea was laudable, but, as Dilworth discovered upon examining the page proofs, Carr's text had been seriously tampered with. The publisher changed some of Carr's wording and eliminated entire sections of text that it thought might present ideas too controversial for the classroom. Dilworth wrote at once to question why:

> When I came to study the page proof of *Klee Wyck* carefully, I was very much disappointed to find that omissions and excisions had been so extensive. It is rather difficult for me to see on what principle decisions to omit phrases, sentences and paragraphs were arrived at. If these decisions are not yet irrevocable, I should like to bring some points to your attention for consideration, since I

was not consulted at all before the decisions were arrived at. "Ucluelet" is, of course, the heaviest sufferer.[21]

The reply he received from Clarke, Irwin explained:

> As you know, our main purpose in doing Miss Carr's books in the Canadian Classics edition was to bring a wider knowledge of her work and her writings to the schools in all the provinces. We were anxious that nothing should be allowed to prejudice that aim, and the question was raised whether some references to missionaries in one or two of the early essays might offend any members of the teaching profession. That was one problem. Another was whether anyone had the right to make any excision of any material written by Emily Carr.... The feeling of all of us was against any omission from *Klee Wyck*, but when this question was put to some representative educational authorities, they were overwhelmingly in favour of excising the occasional passage which might be misconstrued. For example, on page 4 of the trade edition, a sentence reads "After breakfast came a long Presbyterian prayer." It was indicated that it perhaps would be better if the word "Presbyterian" were dropped. This, then, together with a fixed determination to do no violence either to the spirit of Miss Carr's writings or to their style, was the principle on which decisions to excise were arrived at. Each omission was very carefully considered, and all were kept to an absolute minimum.[22]

Dilworth was furious:

> You say that you had a fixed determination to do no violence to the spirit or style of Miss Carr's writing and I am sure you make

this statement in good faith but in my opinion you have not been successful in avoiding just that. I know Emily was inclined always to ride a horse hard but this question of the attitude of the missionaries towards Indian customs and even the Indians themselves was not a hobby-horse. It was a deep conviction and in "Ucluelet" she spoke clearly, simply and honestly out of that conviction. I can quite see that some of the things that she said might be offensive in a school textbook but I really think you have gone too far....I am concerned that the degree of expurgation to which the text is subjected should not lead Emily's friends who know and revere the text very highly to be embarrassingly critical of the edition.[23]

Dilworth did not succeed in his attempt to retain Carr's original text. In all, more than 2300 words were removed, including almost every derogatory adjective or descriptor concerning missionaries at Ucluelet and other places, observations concerning their negative reactions to First Nations beliefs, a passage describing a musty church interior and references to residential schools.[24] "Ucluelet" lost more than 800 words, including the last two pages, which described the Native way of burying their dead in box platforms set in trees. "Friends" lost some 360 words: the last two pages of the story, and, tellingly, the section in which Carr shows her contempt for missionaries by refusing to suggest to her Native friend Louisa that her only children should be sent away from home to attend residential school.

"Martha's Joey," a story of just over 500 words was eliminated altogether. In many ways this is one of Carr's most poignant sketches, recording her own family's reaction of helplessness and

sorrow at the plight of a Native woman who had rescued and raised an abandoned white baby, only to later have her Joey taken away from her because she was Native. Carr's anger at the cruelty caused by this racially based decision to remove the child, which is evident in her account of Martha's anguish, was a cutting condemnation of the status quo.

These challenges of Emily Carr's to prevailing social attitudes were deemed improper to be read by schoolchildren. As well, some of the stories dealt with schooling and attendance in a disparaging way, posing a double threat to the complacency of the classroom. The fact that Carr's views were difficult subject matter for the classroom and that the publisher made the expurgations speak volumes for the times. Dilworth did manage to get in a tiny reference to his frustration in the final paragraph of his new foreword. "I am convinced that the experience of reading it will lead you to make further excursions into the work of this remarkable woman, into her paintings and her other books—into *Klee Wyck* in its full form (some passages have been omitted in this edition)."[25] However, in subsequent printings, his allusion to the expurgation was removed.

The "violation" of Carr's work was raised by the Clarke, Irwin and Company editorial board, but dismissed. That is, did anyone have the right to expurgate Carr's work? The Canadian Copyright Act stated the author has the right to restrain any distortion, mutilation or other modification of the work that would be prejudicial to her honour or reputation.[26] But who advocates on behalf of a deceased author? Dilworth was Carr's literary executor and received royalties from her publications, but his objections to the expurgations went nowhere. Perhaps faced with a public legal

battle, Dilworth chose to remain quiet, thinking that the original full text would remain available in addition to the educational edition. But little did he know…

A lingering consequence of the 1951 expurgated "educational edition" is that it is the only version that has been available for more than fifty years. The full text has not been restored until now, in this edition.

Reading this complete *Klee Wyck* afresh, within the context of today's social attitudes and a knowledge of historical events, allows us to evaluate Carr in a new light. She was, it is true, strident and unforgiving, niggling away at the missionaries and their ways, and one critic commented that "Her irony is like the slash of a razor."[27] And Carr has First Nations characters Sophie and Mrs. Green speak in a pidgin English, such as "I t'ink 'spose boat no come quick, Milly die plitty soon now," which rankles today, but she does not patronize. George Clutesi, the Nuu-chah-nulth artist to whom she bequeathed her paints and brushes, acknowledged that Carr was an important ally for furthering understanding of First Nations, describing her as "a person of meaning." He admired *Klee Wyck* and, according to an interviewer, was not conscious of any special condescension in it.[28]

Klee Wyck is both beloved and a classic for many good reasons: it is a prescient social statement, an act of passionate advocacy and, above all, a work of art that offers pure literary delight. We marvel at Emily Carr's deftness at painting pictures with words and at the seeming simplicity of her style. Less is more, and she worked hard at achieving it. The descriptions of people and the landscape are both evocative and memorable. The stories are intimate, but not sentimental, and thus have retained their power through the years. Her writing has not dated, for even in our

time, she is still being praised as "a magical wordsmith whose gorgeous prose reflects a desire for simplicity even as it sensually mirrors life in its teeming complexity."[29]

Early on, Carr worried about how the public would react to her stories, but she need not have, for she wrote from her soul. "Probably when people do not know the places or people ... [the stories] will be flat but they are true and I would rather they were flat than false. I tried to be plain, straight, simple and Indian. I wanted to be true to the places as well as to the people. I put my whole soul into them and tried to avoid sentimentality. I went down deep into myself."[30]

ENDNOTES

1. Emily Carr, *Growing Pains* (Toronto: Clarke, Irwin and Company, 1966), p. 265.

2. I would like to thank Gerta Moray, author of *Unsettling Encounters: The "Indian" Pictures of Emily Carr* (forthcoming) for the stimulating and wide-ranging Carr discussions during the research for her doctoral dissertation, "Northwest Coast Native Culture and the Early Indian Paintings of Emily Carr," University of Toronto, 1993.

3. This book is based on the original 1941 published version, but some minor changes have been made. In "Ucluelet," the Chinook word "hiyu" is now correctly "hiyu," as it is later in the book. In "Cumshewa," the spelling of "Jimmy" was changed to "Jimmie" for consistency within that story and others in which he appears. In "Sophie," "gray-green" is now "grey-green" to agree with the spelling of "grey" and "grave flower" changed to "glave flower" for consistency. "Griffon" was inconsistently capitalized and has been made lower case throughout. "Skidigate" is now "Skidegate" for correctness and consistency. The capitalization (or not) of the word "missionary" was made uniform within each story. The use of "on to" was changed to "onto" throughout. A very few minor changes to punctuation were made for uniformity of usage.

4. In Ira Dilworth's foreword to the 1951 edition, the passages that he quoted from "Century Time" and "Canoe" in *Klee Wyck* are slightly different from the published versions, in particular the quotation from "Century Time": the sentence "Cased only in a box it is laid in a shallow grave" is not in the published book; perhaps he was looking at a manuscript version. He also quotes from a passage in *Bobtails:* it comes from the story "Beacon Hill" in the collection titled *Bobtails,* published in the book *The House of All Sorts*. Dilworth's foreword was altered at some later point: sections ii and vi were deleted and slight changes made to the opening sentences of iii and iv.

5. Carr says in *Growing Pains* that she wrote the stories while in the hospital, but her journal *Hundreds and Thousands* states that it took her some time to recuperate before she was able to pick up a pencil or pen; when she did, she tackled many of the stories she had begun a decade earlier, reworking and organizing them by theme. The stories about her experiences in Native communities that form *Klee Wyck* were largely completed by August 1937.

6. These latter stories later formed the core of *The Book of Small*, published in 1942.

7. Carr's "listening ladies" included, at various times, Flora Hamilton Burns (with whom she had enrolled in a correspondence school writing course in 1926), Margaret Clay and Ruth Humphrey.

8. Emily Carr to Nan Cheney, 24 March 1941, University of British Columbia Special Collections.

9. Carr to Cheney, 27 October 1941, University of British Columbia Special Collections.

10. Robertson Davies, "The Revelation of Emily Carr," *Saturday Night Magazine*, November 1941.

11. Review of *Klee Wyck* in *Echoes*, the official publication of the IODE, Christmas 1941.

12. Davies, "The Revelation of Emily Carr."

13. Emily Carr, "A Kiss for Canada" in *Growing Pains: The Autobiography of Emily Carr* (Toronto: Clarke, Irwin and Company, 1946); and "Victoria Pays Honor to Great Canadian Artist," *Victoria Daily Colonist*, 14 December 1941.

14. "Emily Carr Among Indians with Facile Pen and Brush," *Vancouver Daily Province*, 29 November 1941.

15. Review of *Klee Wyck* in *Echoes*.

16. Blair Fraser, "Emily Carr and the Indians," *Montreal Gazette*, 8 November 1941.

17. "Indian Ways," *New York Times Book Review*, 7 June 1942.

18. William H. Clarke to Emily Carr, 16 September 1942, MS 2763, Emily Carr Papers, British Columbia Archives.

19. Emily Carr to Ira Dilworth, dated Monday [September 1942]: "Its [*sic*] come & not much to look at!" MS2181, Emily Carr Papers, British Columbia Archives.

20. R.W.W. Robertson, editor, Clarke, Irwin and Company, to Ira Dilworth, 19 March 1951 and 9 April 1951. Clarke, Irwin and Company Ltd. fonds, McMaster University Library.

21. Dilworth to Robertson, 9 April 1951. Clarke, Irwin and Company Ltd. fonds, McMaster University Library.

22. Robertson to Dilworth, 10 April 1951, Clarke, Irwin and Company Ltd. fonds, McMaster University Library.

23. Dilworth to Robertson, 17 April 1951. Clarke, Irwin and Company Ltd. fonds, McMaster University Library.

24. The major missing sentences and paragraphs are detailed by Susan Crean in her book *Opposite Contraries: The Unknown Journals of Emily Carr and Other Writings* (Vancouver/Toronto: Douglas & McIntyre, 2003).

25. Ira Dilworth, foreword to the educational edition of *Klee Wyck* (Toronto: Clarke, Irwin and Company, 1951).

26. According to the Canadian Copyright Act, 1921, an author has the right to control the presentation of the work. This "moral right" is separate from copyright and can be waived but not assigned. Subsequent changes to the act have clarified an author's moral rights.

27. Davies, "The Revelation of Emily Carr."

28. Notes taken by Edythe Hembroff-Schleicher of a conversation with George Clutesi, 24 December 1974. MS 2792, Edythe Hembroff-Schleicher Papers, British Columbia Archives.

29. Review of *The Emily Carr Omnibus* (later reissued as *The Collected Writings of Emily Carr*) in *Publishers Weekly,* 27 September 1993.

30. Entry for 24 June 1937, Emily Carr, *Hundreds and Thousands: The Journals of Emily Carr* (Toronto: Clarke, Irwin and Company, 1966).

"IF IT BE true that good wine needs no bush, 'tis true that a good play needs no epilogue. Yet to good wine they do use good bushes: and good plays prove the better by the help of good epilogues. What a case am I in then that am neither a good epilogue nor cannot insinuate with you in behalf of a good play..."

My plight is much less difficult than Rosalind's. I am not an epilogue at all, good or bad—in fact I should hate to be an epilogue. I have no other function to perform than to open the door for you and invite you into a new experience. I am also in better case than she, if we may trust her own statement, in that I can insinuate with you in behalf of a good book.

IT SEEMS ALMOST an impertinence that I should tell readers who Miss Carr is—my brief note concerning her must seek its justification in the fact that in the present volume she makes her very first appearance as a literary figure.

Born almost seventy years ago in Victoria of English parentage, Emily Carr is a thorough-going, downright Canadian. She early gave evidence of unusual interest and talent in drawing, promise

richly realized in the ample and distinguished achievement of her painting. In her early teens she ventured into the then reputedly wicked city of San Francisco to train at the Art School there. With the exception of that period, a sojourn of some years in England and another in France, Miss Carr has lived her whole life in Western Canada which she loves with deep loyalty. Here she has worked at her art with singular devotion and courage despite the indifference and, at times, even hostility of her friends and fellow citizens. Perhaps it is because of public neglect of her early work that she developed in her painting a style so individual and sincerely personal that it seems to me presumptuous to try to analyze it, looking as usual for influences and tendencies, and quite futile to come with labels all ready to smack onto this Canadian woman's vital, vivid work.

TO A FEW OF her closest friends it became known some time ago that Miss Carr had for years been writing, setting down in simple, unaffected prose, early experiences of her childhood in Victoria or later adventures in Indian villages of the British Columbia Coast. This writing has been done for no other reason than to provide occasional escape and relaxation for the artist, or, at times, to fix clearly in her mind sequences of events and impressions of people and places, the edges of which might become dim. It has none of the too frequent self-consciousness which makes tedious reading of reminiscences prepared intentionally for the public.

Klee Wyck is made up of sketches written at various times and brought together and published now for the first time. Long ago when it was her habit in summers to go into wild, lonely places seeking Indian subjects, Miss Carr's artist mind received

impressions which have remained sharp and real for her across the years. By fish-boat, gas-boat, sometimes by Indian canoe, taking with her a few books, at least one dog and her sketching kit, she penetrated forest and village on the British Columbia coast, even going on occasion over to the Queen Charlottes. The vivid images stored then in her mind have been brooded over since by her rich imaginative faculty and the result is an unusual collection of sketches in words, not paint.

The name *Klee Wyck* is in itself interesting and a word of explanation is perhaps justifiable. It was the name which the Indians gave Miss Carr at Ucluelet. It meant "Laughing One" and was given to her not because she laughed a great deal—as she herself would say, there is not much of "giggle" in her. But her laughter in Ucluelet went out to meet the Indians, taking the place of words, forming a bond between them. They felt at once that the young girl staying in the missionaries' house understood them and they accepted her....

BUT YOU WILL think me a churlish porter if I any longer hold closed the door and exclude you from a gallery through which I have myself moved with delight.

Ira Dilworth
Vancouver, B.C.
October, 1941

I

MY EARLIEST VIVID memories of Emily Carr go back to a period considerably more than a quarter of a century ago, to a time when she was living in Victoria, British Columbia, still largely unnoticed as an artist and, by most of those who did know her in that capacity, unappreciated or treated with ridicule and even hostility. In those days she was a familiar figure passing down Simcoe Street in front of our house which was little more than a stone's throw away from her home. With methodical punctuality by which you could almost have set your clock, she passed by each morning on her way to the grocer's or butcher's. She trundled in front of her an old-fashioned baby carriage in which sat her favourite pet, Woo, a small Javanese monkey dressed in a bright costume of black, red and brown which Emily had made for her. Bounding around her as she went would be six or eight of the great shaggy sheep dogs which she raised for sale. Half an hour later you could see her returning, the baby carriage piled high with parcels, Woo skipping along at the end of a leash, darting

under the hedge to catch succulent earwigs which she loved to crunch or sometimes creeping right through the hedge into the garden to have her tail pulled by the children hiding there. The great sheep dogs still bounced around the quaint figure whom they recognized as their devoted mistress. I thought of her then, as did the children behind the hedge and as did most of her fellow-citizens who thought of her at all, as an eccentric, middle-aged woman who kept an apartment house on Simcoe Street near Beacon Hill Park, who surrounded herself with numbers of pets—birds, chipmunks, white rats and the favourite Woo—and raised English sheep dogs in kennels in her large garden.

II

BUT IT IS NOT my intention to set down the facts of Emily Carr's life—how she was born in Victoria of English parentage and spent her life in that city, with brief interruptions for study of painting in San Francisco, England, and France, how she pursued in the face of many obstacles her long struggle to master her chosen art, how she gradually achieved a measure of recognition and fame before her death in 1945 in the city where she was born. The story of her life is a fascinating one, a piece of true Canadiana, but the details, for those who are curious to know them, can be discovered in many sources, notably in her own autobiography, *Growing Pains*.

It is the purpose of this note, rather, to indicate several reasons why this new educational edition of *Klee Wyck* is a welcome and significant addition to the Canadian literary works available for young people in our schools and colleges.

III

IN THE FIRST place Emily Carr was a great painter, certainly one of the greatest women painters of any time. It has been said that for originality, versatility, driving creative power and strong, individual achievement she has few equals among modern artists. Her talent in drawing revealed itself when she was still a small child and was encouraged by her father. Emily set herself early and with singleness of devotion to master the technique of painting and, despite discouragement and many difficulties, worked with great courage and experimental enthusiasm until the time of her death.

After the turn of the century, with study in San Francisco and England behind her, she became particularly concerned with the problem of devising a style in painting which would make it possible for her to express adequately not only what she saw but also what she felt in her subject matter—the great totem poles, tribal houses and villages of the West Coast Indians and, later, the tangled, solemn, majestic beauty of the Pacific Coast forest. Nothing ever meant so much to her as the struggle to gain that power; she was never satisfied that she had achieved her aim. In this connection, therefore, it is interesting to have the opinion of Lawren Harris, himself a great original Canadian painter and for years one of Emily Carr's closest and most valued friends. He says in an article, "The Paintings and Drawings of Emily Carr",

> It (British Columbia) is another world from all the land east of the Great Divide. Emily Carr was the first artist to discover this. It involved her in a conscious struggle to achieve a technique that would match the great, new motifs of British Columbia. It was primarily this long and deepening discovery which made her

work modern and vital, as it was her love of its moods, mystery and majesty that gave it the quality of indwelling spirit which the Indians knew so well. It was also her life with the Indians and their native culture which led her to share and understand their outlook on nature and life, and gave her paintings of totems, Indian villages and the forest a quality and power which no white person had achieved before.

IV

IN THE SECOND place, Emily Carr is now also recognized as a remarkable writer. Her diaries, which first came to light after her death and remain still unpublished, make it clear that her desire to express herself in words began in the late 1920's. As in the case of her painting, she worked very hard to master this medium. She was fascinated by the great range of new possibilities which it opened up but mastery of it did not come easily.

Why did she turn to writing? Sometimes, undoubtedly, merely for comfort in her loneliness, sometimes quite consciously to relive experiences of the past. She once told me that, when she was working on the first stages of a painting, trying to put down in pictorial form a subject for which she had made field sketches, she found it of great value to "word" her experience. In this way, she said, the circumstances and all the details of the incident or place would come back to her more vividly and she could reconstruct them more faithfully than was possible with paint and canvas alone. From this developed, I suspect, one of the controlling principles of her method and style in literary composition.

I have seen her "peeling" a sentence, as she called it,—a process which involved stripping away all ambiguous or unnecessary words, replacing a vague word by a sharper, clearer one until the

sentence emerged clean and precise in its meaning and strong in its impact on the reader. As a result, there is in her writing the quality of immediacy, the ability, by means of descriptive words chosen with the greatest accuracy, to carry the reader into the very heart of the experience she is describing, whether it be an incident from her own childhood or a sketch of an Indian and his village—and that so swiftly as to give an impression almost of magic, of incantation.

She has spoken many times in her diaries of the difficulties she had to overcome in writing. Late in October, 1936, she made a characteristic, vivid entry:

> There's words enough, paint and brushes enough and thoughts enough. The whole difficulty seems to be getting the thoughts clear enough, making them stand still long enough to be fitted with words and paint. They are so elusive—like wild birds singing above your head, twittering close beside you, chortling in front of you, but gone the moment you put out a hand. If ever you do catch hold of a piece of a thought it breaks away leaving the piece in your hand just to aggravate you. If one only could encompass the whole, corral it, enclose it safe—but then maybe it would die, dwindle away because it could not go on growing. I don't think thoughts could stand still—the fringes of them would always be tangling into something just a little further on and that would draw it out and out. I guess that is just why it is so difficult to catch a complete idea—it's because everything is always on the move, always expanding.

A very closely related characteristic of her writing is its sincerity. I shall let her speak again for herself in her own forceful, inimitable style.

Be careful that you do not write or paint anything that is not your own, that you don't know in your own soul. You will have to experiment and try things out for yourself and you will not be sure of what you are doing. That's all right, you are feeling your way into the thing. But don't take what someone else has made sure of and pretend that it's you yourself that have made sure of it, till it's yours absolutely by conviction. It's stealing to take it and hypocrisy and you'll fall in a hole.... If you're going to lick the icing off somebody else's cake you won't be nourished and it won't do you any good,—or you might find the cake had caraway seeds and you hate them. But if you make your own cake and know the recipe and stir the thing with your own hand it's your own cake. You can ice it or not as you like. Such lots of folks are licking the icing off the other fellow's cake!

Consequently, Emily Carr's style is characterized by a great simplicity and directness—a simplicity, it's true, that is a little deceptive in view of the sustained discipline from which it resulted—but perhaps it is just in that way that the only true simplicity is achieved. Words are used by her with great courage, sometimes taking on new and vivid meanings. They are in her writing the equivalent of the quick, sure brush strokes and dramatic, strong colours which are so characteristic of her canvases.

It has been remarked by many readers—and with justification —that Emily Carr's prose style has much in common with poetry. This is to be seen in her rigid selectivity in the use of diction described above, in her daring use of metaphorical language, in the rhythm, the cadence of her writing and in her consciousness of form. Look, for instance, at this passage from "Century Time":

In the late afternoon a great shadow mountain stepped across the lake and brooded over the cemetery. It had done this at the end of every sunny day for centuries, long, long, before that piece of land was a cemetery. Dark came and held the shadow mountain there all night, but when morning broke, it was back again inside its mountain, which pushed its grand purple dome up into the sky and dared the pines swarming around its base to creep higher than half way up its bare rocky sides.

Indians do not hinder the progress of their dead by embalming or tight coffining. When the spirit has gone they give the body back to the earth. Cased only in a box it is laid in a shallow grave. The earth welcomes the body—coaxes new life and beauty from it, hurries over what men shudder at. Lovely tender herbage bursts from the graves—swiftly—exulting over corruption.

and again at this passage from "Bobtails":

The top of Beacon Hill was bare. You could see north, south, east and west. The dogs rested, tongues lolling, while I looked at the new day, at the pine trees, at the sky, at the sea where it lay flat, and at the near broom bushes drooped with early morning wetness. The song of the meadow-lark crumbled away the last remnants of night, three sad lingering notes followed by an exultant double note that gobbled up the still vibrating three. For one moment the morning took you far out into vague chill; your body snatched you back into its cosiness, back to the waiting dogs on the hill top. They could not follow out there; their world was walled, their noses trailed the earth.

or at this from "Canoe":

> The canoe passed shores crammed with trees, trees overhanging stoney beaches, trees held back by rocky cliffs, pointed fir trees climbing in dark masses up the mountain sides, moonlight silvering their blackness.
>
> Our going was imperceptible, the woman's steering paddle the only thing that moved, its silent cuts stirring phosphorus like white fire.
>
> Time and texture faded, ceased to exist—day was gone, yet it was not night. Water was not wet or deep, just smoothness spread with light.

Such writing transcends the usual limits of prose and becomes (but without aesthetic offence) lyrical.

The quality of form, not a surprising attribute in view of her distinction as a painter, can be seen over and over again but notably in the exquisite lyric, "White Currants", in the simply shaped but touchingly effective "Sophie" and in "D'Sonoqua" which has the quality of a musical symphony with its dominant themes, its sectional development and its use of suspense and tense emotional crescendo.

As a final point in this discussion of Emily Carr's literary style it should be noted that she was not a great reader. Her style is, therefore, not the result of imitation of literary models. Undoubtedly it is better so, for the originality and simplicity which marked all her work, whether in painting, rug-making, pottery or writing, remained uninhibited by academic literary standards. Of these Miss Carr knew little or nothing. But there is some literary influence. She was a devoted reader of the poems of Walt Whitman, attracted to them by Whitman's deep feeling for nature and by his vigorous style. There is too, I think, a discernible influence at

times of the Bible, notably of the Psalms, and of the English
Prayerbook.

V

BUT ABOVE EVERYTHING else, Emily Carr was a truly great
Canadian. Her devotion to her own land marked everything she
did. She approached no subject in writing or painting with any
condescension or purely artistic self-consciousness. She was
driven always by a passion to make her own experience in the
place in which life had set her vivid and real for the onlooker or
the reader and to do this with dignity and distinction. She found
life in her part of Canada often hard and baffling but always rich
and full. It was her single purpose to share through the medium of
her art and in as memorable a fashion as possible the experiences
of her life. She was never happy outside Canada. Indeed, during
her sojourns in England and France she was the victim of such
overwhelming homesickness that she became physically ill and
was ordered by her physician to return to her Canadian home.

She was an amazing woman. May I take the liberty of quoting
a note which I set down in 1941? I hold the views as firmly today
as then:

I have heard her talking and watched her devour the conversa-
tion of others, of Lawren Harris, of Arthur Benjamin, of Garnett
Sedgewick; I have watched her anger tower over some meanness
in the work or conduct of an artist and I have seen her become
incandescent with generous enthusiasm for another's fine work;
I have seen her gentleness to an old woman and to an animal; I
have beheld the vision of forest and sky enter and light her eyes
as she sat far from them—and I am convinced that Emily Carr is

a great genius and that we will do well to add her to that small list of originals who have been produced in this place and have lived and commented in one way or another on this Canada of ours.

Emily Carr was herself more modest. Asked a few years before her death to state what had been the outstanding events of her life, she wrote,

Outstanding events!—work and more work! The most outstanding seems to me the buying of an old caravan trailer which I had towed to out-of-the-way corners and where I sat self-contained with dogs, monk and work—Walt Whitman and others on the shelf—writing in the long, dark evenings after painting—loving everything terrifically. In later years my work had some praise and some successes, but the outstanding event to me was the doing which I am still at. Don't pickle me away as a "done".

It is impossible to think of that vivid person as a "done". No, she goes on in her work. As surely as Wordsworth marked the English Lake District with his peculiar kind of seeing and feeling, leaving us his experience patterned in poetry, so surely this extraordinary, sensitive, gifted Canadian touched a part of our landscape and life and left her imprint there so clearly that now we, who have seen her canvases or read her books must feel, as we enter the vastness of the western forest or stand before a totem pole or in the lonely ruin of an Indian village, less bewildered and alone because we recognize that another was here before us and humanized all this by setting down in paint or words her reaction to it.

VI

AND SO I welcome the opportunity to introduce young Canadians to this book of Emily Carr. I am convinced that the experience of reading it will lead you to make further excursions into the work of this remarkable woman, into her paintings and her other books—into *Klee Wyck* in its full form (some passages have been omitted in this edition), into *The House of All Sorts, Bobtails* and *Growing Pains*. And the reading of this vital Canadian prose will, I am sure, enrich and fill out your own experience, giving more significance to the things that you in common with Emily Carr meet in your everyday life.

Ira Dilworth
Robin Hill,
Knowlton, P.Q.,
June, 1951

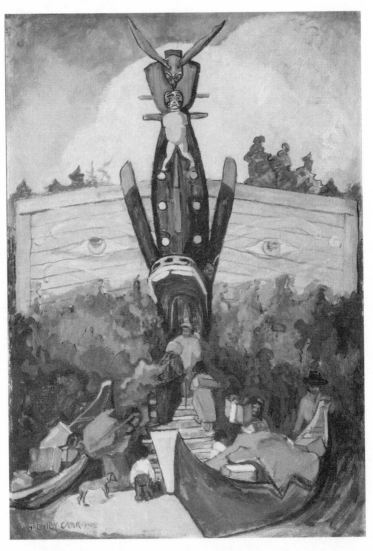

Emily Carr, *Old Indian House, Northern British Columbia Indians Returning from Canneries to Guyasdoms Village,* 1912, oil on paperboard, 97.0 × 66.0 cm, Vancouver Art Gallery, Emily Carr Trust, VAG 42.3.51 (photo by Trevor Mills)

❧ UCLUELET ❧

THE LADY MISSIONARIES expected me. They sent an enormous Irishman in a tiny canoe to meet the steamer. We got to the Ucluelet wharf soon after dawn. Everything was big and cold and strange to me, a fifteen-year-old school-girl. I was the only soul on the wharf. The Irishman did not have any trouble deciding which was I.

It was low tide, so there was a long, sickening ladder with slimy rungs to climb down to get to the canoe. The man's big laugh and the tippiness of the canoe were even more frightening than the ladder. The paddle in his great arms rushed the canoe through the waves.

We came to Toxis, which was the Indian name for the Mission House. It stood just above high-tide water. The sea was in front of it and the forest behind.

The house was of wood, unpainted. There were no blinds or curtains. It looked, as we paddled up to it, as if it were stuffed with black. When the canoe stuck in the mud, the big Irishman picked me up in his arms and set me down on the doorstep.

The Missionaries were at the door. Smells of cooking fish jumped out past them. People lived on fish at Ucluelet.

Both the Missionaries were dignified, but the Greater Missionary had the most dignity: the Lesser Missionary was fussy. They had long pale faces. Their hair was licked from their foreheads back to buns on the scruffs of their necks. They had long noses straddled by spectacles, thin lips, mild eyes, and wore straight, dark dresses buttoned to the chin.

There was only two of everything in the kitchen, so I had to sit on a box, drink from a bowl and eat my food out of a tin pie-dish.

After breakfast came a long Presbyterian prayer. Outside the kitchen window, just a few feet away at the edge of the forest, stood a grand balsam pine tree. It was very tall and straight.

The sizzling of the Missionaries' "trespasses" jumped me back from the pine tree to the Lord's Prayer just in time to "Amen". We got up from our knees to find the house full of Indians. They had come to look at me.

I felt so young and empty standing there before the Indians and the two grave Missionaries! The Chief, old Hipi, was held to be a reader of faces. He perched himself on the top of the Missionaries' drug cupboard; his brown fists clutched the edge of it, his elbows taut and shoulders hunched. His crumpled shoes hung loose as if they dangled from strings and had no feet in them. The stare of his eyes searched me right through. Suddenly they were done; he lifted them above me to the window, uttered several terse sentences in Chinook, jumped off the cupboard and strode back to the village.

I was half afraid to ask the Missionary, "What did he say?"

"Not much. Only that you had no fear, that you were not stuck up, and that you knew how to laugh."

TOXIS SAT UPON a long, slow lick of sand, but the beach of the Indian village was short and bit deep into the shoreline. Rocky points jutted out into the sea at either end of it.

Toxis and the village were a mile apart. The schoolhouse was half-way between the two and, like them, was pinched between sea and forest.

The schoolhouse called itself "church house" on Sundays, and looked as Presbyterian as it could under the circumstances.

It had a sharp roof, two windows on each side, a door in front, and a woodshed behind.

The school equipment consisted of a map of the world, a blackboard, a stove, crude desks and benches and, on a box behind the door, the pail of drinking-water and a tin dipper.

The Lesser Missionary went to school first and lit the fire. If the tide were high she had to go over the trail at the forest's edge. It was full of holes where high seas had undermined the big tree roots. Huge upturned stumps necessitated detours through hard-leafed sallal bushes and skunk cabbage bogs. The Lesser Missionary fussed her way jumpily. She hated putting her feet on ground which she could not see, because it was so covered with growing green. She was glad when she came out of the dark forest and saw the unpainted schoolhouse. The Greater Missionary had no nerves and a long, slow stride. As she came over the trail she blew blasts on a cow's horn. She had an amazing wind, the blasts were stunning, but they failed to call the children to school, because no voice had ever suggested time or obligation to these Indian children. Then the Greater Missionary went to the village and hand-picked her scholars from the huts.

On my first morning in Ucluelet there was a full attendance at school because visitors were rare. After the Lord's Prayer the Missionaries duetted a hymn while the children stared at me.

When the Missionary put A, B, C on the board the children began squirming out of their desks and pattering down to the drinking bucket. The dipper registered each drink with a clank when they threw it back.

The door squeaked open and shut all the time, with a second's pause between opening and closing. Spitting on the floor was forbidden, so the children went out and spat off the porch. They had not yet mastered the use of the pocket-handkerchief, so not a second elapsed between sniffs. The Lesser Missionary twitched as each sniff hit her ear.

Education being well under way, I slipped out to see the village.

When I did not return after the second's time permitted for spitting, the children began to wriggle from the desks to the drinking bucket, then to the spitting step, looking for me. Once outside, their little bare feet never stopped till they had caught me up. In the empty schoolroom the eyes of the Lesser Missionary waited upon those of the Greater as the shepherd's dog watches for the signal to dash.

"That is all for today," the older woman said quietly and they went home.

After that I was shut up tight at Toxis until school was well started; then I went to the village, careful to creep low when passing under the school windows.

On the point at either end of the bay crouched a huddle of houses—large, squat houses made of thick, hand-hewn cedar planks, pegged and slotted together. They had flat, square fronts.

The side walls were made of driftwood. Bark and shakes, weighted with stones against the wind, were used for roofs. Every house stood separate from the next. Wind roared through narrow spaces between.

Houses and people were alike. Wind, rain, forest and sea had done the same things to both—both were soaked through and through with sunshine, too.

I was shy of the Indians at first. When I knocked at their doors and received no answer I entered their houses timidly, but I found that a grunt of welcome was always waiting inside and that Indians did not knock before entering. Usually some old crone was squatted on the earth floor, weaving cedar fibre or tatters of old cloth into a mat, her claw-like fingers twining in and out, in and out, among the strands that were fastened to a crude frame of sticks. Papooses tumbled round her on the floor for she was papoose-minder as well as mat-maker.

Each of the large houses was the home of several families. The door and the smoke-hole were common to all, but each family had its own fire with its own things round it. That was their own home.

The interiors of the great houses were dim. Smoke teased your eyes and throat. The earth floors were not clean.

It amused the Indians to see me unfold my camp stool, and my sketch sack made them curious. When boats, trees, houses appeared on the paper, jabbering interest closed me about. I could not understand their talk. One day, by grin and gesture, I got permission to sketch an old mat-maker. She nodded and I set to work. Suddenly a cat jumped in through the smoke-hole and leaped down from a rafter onto a pile of loose boxes. As the clatter of the topple ceased there was a bestial roar, a pile of mats

and blankets burst upwards, and a man's head came out of them. He shouted and his black eyes snapped at me and the old woman's smile dried out.

"Klatawa" (Chinook for "Go") she shouted, and I went. Later, the old wife called to me across the bay, but I would not heed her call.

"Why did you not reply when old Mrs. Wynook called you?" the Missionary asked.

"She was angry and drove me away."

"She was calling, 'Klee Wyck, come back, come back,' when I heard her."

"What does 'Klee Wyck' mean?"

"I do not know."

The mission house door creaked open and something looking like a bundle of tired rags tumbled onto the floor and groaned.

"Why, Mrs. Wynook," exclaimed the Missionary, "I thought you could not walk!"

The tired old woman leaned forward and began to stroke my skirt.

"What does Klee Wyck mean, Mrs. Wynook?" asked the Missionary.

Mrs. Wynook put her thumbs into the corners of her mouth and stretched them upwards. She pointed at me; there was a long, guttural jabber in Chinook between her and the Missionary. Finally the Missionary said, "Klee Wyck is the Indians' name for you. It means 'Laughing One'."

The old woman tried to make the Missionary believe that her husband thought it was I, not the cat, who had toppled the boxes and woke him, but the Missionary, scenting a lie, asked for "straight talk". Then Mrs. Wynook told how the old Indians

thought the spirit of a person got caught in a picture of him, trapped there so that, after the person died, it had to stay in the picture.

"They have such silly notions," said the Missionary.

"Tell her that I will not make any more pictures of the old people," I said. It must have hurt the Indians dreadfully to have the things they had always believed trampled on and torn from their hugging. Down deep we all hug something. The great forest hugs its silence. The sea and the air hug the spilled cries of sea-birds. The forest hugs only silence; its birds and even its beasts are mute.

WHEN NIGHT CAME down upon Ucluelet the Indian people folded themselves into their houses and slept.

At the mission house candles were lit. After eating fish, and praying aloud, the Missionaries creaked up the bare stair, each carrying her own tin candlestick. I had a cot at the foot of their wide wooden bed and scrambled quickly into it. Blindless and carpetless, it was a bleak bedroom even in summer.

The Missionaries folded their clothes, paired their shoes, and put on stout nightgowns. Then, one on each side of the bed, they sank to their knees on the splintery floor and prayed some more, this time silent, private prayers. The buns now dangled in long plaits down their backs and each bowed head was silhouetted against a sputtering candle that sat on an upturned apple-box, one on either side of the bed, apple-boxes heaped with devo-tional books.

The room was deathly still. Outside, the black forest was still, too, but with a vibrant stillness tense with life. From my bed I could look one storey higher into the balsam pine. Because of

his closeness to me, the pine towered above his fellows, his top tapering to heaven like the hands of the praying Missionaries.

EVERY DAY MIGHT have been a Sunday in the Indian village. At Toxis only the seventh day was the Sabbath. Then the Missionaries changed their "undies" and put lace jabots across the fronts of their "ovies", took an hour longer in bed in the morning, doubled their doses of coffee and prayers, and conducted service in the schoolhouse which had shifted its job to church as the cow's horn turned itself into a church bell for the day.

The Indian women with handkerchiefs on their heads, plaid shawls round their shoulders and full skirts billowing about their legs, waddled leisurely towards church. It was very hard for them to squeeze their bodies into the children's desks. They took two whole seats each, and even then the squeezing must have hurt.

Women sat on one side of the church. The very few men who came sat on the other. The Missionaries insisted that men come to church wearing trousers, and that their shirt tails must be tucked inside the trousers. So the Indian men stayed away.

"Our trespasses" had been dealt with and the hymn, which was generally pitched too high or too low, had at last hit square, when the door was swung violently back, slopping the drinking bucket. In the outside sunlight stood old Tanook, shirt tails flapping and legs bare. He entered, strode up the middle of the room and took the front seat.

Quick intakes of horror caught the breath of the women; the Greater Missionary held onto her note, the Lesser jumped an octave.

A woman in the back seat took off her shawl. From hand to hand it travelled under the desks to the top of the room, crossed

the aisle and passed into the hand of Jimmy John, old Tanook's nephew, sitting with the men. Jimmy John squeezed from his seat and laid the shawl across his uncle's bare knees.

The Missionary's address rolled on in choppy Chinook, undertoned by a gentle voice from the back of the room which told Tanook in pure Indian words what he was to do. The Lesser Missionary's eyes popped with indignation. The Greater Missionary's voice went straight on.

With a defiant shake of his wild hair old Tanook got up; twisting the shawl about his middle he marched down the aisles, paused at the pail to take a loud drink, dashed back the dipper with a clank, and strode out.

The service was over, the people had gone, but a pink print figure sat on in the back seat. Her face was sunk down on her chest. She was waiting till all were away before she slunk home. It is considered more indecent for an Indian woman to go shawlless than for an Indian man to go barelegged. The woman's heroic gesture had saved her husband's dignity before the Missionaries but had shamed her before her own people.

The Greater Missionary patted the pink print shoulder as she passed.

"Disgusting old man!" muttered the Lesser Missionary.

"Brave woman!" said the Greater Missionary, smiling.

ONE DAY I walked upon a strip of land that belonged to nothing.

The sea soaked it often enough to make it unpalatable to the forest. Roots of trees refused to thrive in its saltiness.

In this place belonging neither to sea nor to land I came upon an old man dressed in nothing but a brief shirt. He was sawing the limbs from a fallen tree. The swish of the sea tried to drown

the purr of his saw. The purr of the saw tried to sneak back into the forest, but the forest threw it out again into the sea. Sea and forest were always at this game of toss with noises.

The fallen tree lay crosswise in this "nothing's place"; it blocked my way. I sat down beside the sawing Indian and we had dumb talk, pointing to the sun and to the sea, the eagles in the air and the crows on the beach. Nodding and laughing together I sat and he sawed. The old man sawed as if aeons of time were before him, and as if all the years behind him had been leisurely and all the years in front of him would be equally so. There was strength still in his back and limbs but his teeth were all worn to the gums. The shock of hair that fell to his shoulders was grizzled. Life had sweetened the old man. He was luscious with time like the end berries of the strawberry season.

With a final grin, I got up and patted his arm—"Goodbye!" He patted my hand. When he saw me turn to break through the forest so that I could round his great fallen tree, he ran and pulled me back, shaking his head and scolding me.

"Swaawa! Hiyu swaawa!" Swaawa were cougar: the forest was full of these great cats. The Indians forbade their children to go into the forest, not even into its edge. I was to them a child, ignorant about the wild things which they knew so well. In these things the Indian could speak with authority to white people.

NO ONE DISTURBED the Indian dead. Their place was a small, half-cleared spot, a little off from the village and at the edge of the forest. When an Indian died no time was lost in hurrying the body away. While death was approaching a box was got ready. Sometimes, if they owned one, a trunk was used. The body did not lie straight and stark in the box. It was folded up; often it was placed in the box

before it really was a corpse. When life had quite gone, the box was closed, some boards were broken from the side wall of the house, and it was taken away through the hole which was later mended so that the spirit should not remember how it got out and come bothering back.

The people never went to the dead's place except to carry another dead body there and then they would hurry back to make dreadful mourning howls in the village.

One day I went to the place of the dead to sketch. It was creepy. At first I did not know whether I could bear it or not. Bones lay about—human bones—skulls, staring from their eye hollows, stuck out from under the bracken, ribs and thigh bones lay among the roots of the trees where coffin boxes had split. Many "dead-boxes" were bound to the high branches of the pines. The lower limbs of the trees were chopped away. Sometimes a Hudson's Bay blanket would be bound around the box, and flapped in the wind as the tree rocked the box. Up there in the keen air the body disintegrated quickly. The sun and the rain rotted the ropes that bound the box to the tree. They broke and the bones were flung to earth where greenery soon hid them.

It was beautiful how the sea air and sun hurried to help the corpses through their horror. The poor, frail boxes could not keep the elements out; they were quick to make the bones clean and white.

Sometimes Indians used the hollow boles of ancient cedar trees as grave holes, though life was still racing through the cedar's outer shell.

In one of these hollow trees the Indians had lately buried a young woman. They had put her in a trunk. There was a scarlet blanket over the top. Scattered upon that were some beads and

bracelets. There was a brass lamp and her clothes too. The sun streamed in through the split in the side of the tree and sparkled on her dear things. This young dead woman lay in the very heart of the living cedar tree. As I stood looking, suddenly twigs crackled and bracken shivered behind me. My throat went dry and my forehead wet—but it was only Indian dogs.

Up behind Toxis the forest climbed a steep hill and here in the woods was one lonely grave, that of "our only professed Christian Indian", according to the Missionaries. The Missionaries had coffined him tight and carried him up the new-made trail with great difficulty. They put him into the earth among the roots of the trees, away from all his people, away from the rain and the sun and the wind which he had loved and which would have rushed to help his body melt quickly into the dust to make earth richer because this man had lived.

✸ TANOO ✸

JIMMIE HAD A good boat. He and his wife, Louisa, agreed to take me to the old villages of Tanoo, Skedans and Cumshewa, on the southern island of the Queen Charlotte group. We were to start off at the Indian's usual "eight o'clock", and got off at the usual "near noon". The missionary had asked me to take his pretty daughter along.

We chugged and bobbed over all sorts of water and came to Tanoo in the evening. It looked very solemn as we came nearer. Quite far out from land Jimmie shut off the engine and plopped the anchor into the sea. Then he shoved the canoe overboard, and, putting my sheep dog and me into it, nosed it gently through the kelp. The grating of our canoe on the pebbles warned the silence that we were come to break it.

The dog and I jumped out and Jimmie and the canoe went back for the others.

It was so still and solemn on the beach, it would have seemed irreverent to speak aloud; it was if everything were waiting and holding its breath. The dog felt it too; he stood with cocked ears, trembling. When the others came and moved about and spoke this feeling went away.

At one side of the Tanoo beach rose a big bluff, black now that the sun was behind it. It is said that the bluff is haunted. At its foot was the skeleton of a house; all that was left of it was the great beams and the corner posts and two carved poles one at each end of it. Inside, where the people used to live, was stuffed with elder-berry bushes, scrub trees and fireweed. In that part of the village no other houses were left, but there were lots of totem poles sticking up. A tall slender one belonged to Louisa's grandmother. It had a story carved on it; Louisa told it to us in a loose sort of way as if she had half forgotten it. Perhaps she had forgotten some, but perhaps it was the missionary's daughter being there that made her want to forget the rest. The missionaries laughed at the poles and said they were heathenish. On the base of this pole was the figure of a man; he had on a tall, tall hat, which was made up of sections, and was a hat of great honour. On the top of the hat perched a raven. Little figures of men were clinging to every ring of honour all the way up the hat. The story told that the man had adopted a raven as his son. The raven turned out to be a wicked trickster and brought a flood upon his foster parents. When the waters rose the man's nephews and relations climbed up the rings of his hat of honour and were thus saved from being drowned. It was a fine pole, bleached of all colour and then bloomed over again with greeny-yellow mould.

The feelings Jimmie and Louisa had in this old village of their own people must have been quite different from ours. They must have made my curiosity and the missionary girl's sneer seem small. Often Jimmie and Louisa went off hand in hand by themselves for a little, talking in Indian as they went.

A nose of land ran out into the sea from Tanoo and split the village into two parts; the parts diverged at a slight angle, so that the village of Tanoo had a wall-eyed stare out over the sea.

Beyond the little point there were three fine house fronts. A tall totem pole stood up against each house, in the centre of its front. When Jimmie cut away the growth around the foot of them, the paint on the poles was quite bright. The lowest figure of the centre pole was a great eagle; the other two were beavers with immense teeth—they held sticks in their hands. All three base figures had a hole through the pole so that people could enter and leave the house through the totem.

OUR FIRST NIGHT in solemn Tanoo was very strange indeed.

When we saw the Indians carrying the little canoe down to the water we said:

"What are you going out to the boat for?"

"We are going to sleep out there."

"You are going to leave us alone in Tanoo?"

"You can call if anything is wrong," they said. But we knew the boat was too far out beyond the kelp beds for them to hear us.

The canoe glided out and then there was nothing but wide black space. We two girls shivered. I wanted the tent flaps open; it did not seem quite so bad to me if I could feel the trees close. But Miss Missionary wanted them tied tight shut to keep everything out.

Very early in the morning I got to work and two hours later Miss Missionary came out of the tent. The boat lay far out with no sign of life on her. The Indians did not come ashore; it got late and we wanted breakfast—we called and called but there was no answer.

"Do you remember what they said about those Indians being asphyxiated by the fumes from their engine while they slept?"

"I was thinking of that too."

We ran out on the point as far as we could so as to get nearer to the boat and we called and called both together. There was a horrible feeling down inside us that neither of us cared to speak about. After a long while a black head popped up in the boat.

"You must not leave us again like that," we told Jimmie and Louisa.

THE INDIANS WOULD not do a thing for Miss Missionary. They let her collect rushes for her own bed and carry things. The mission house in their home village stood on the hill and looked down on the Indians. But here all of us were on the dead level, all of us had the same mosquito-tormented skins and everything in common, and were wholly dependent on the Indians' knowledge and skill.

I often wondered what Louisa and the white girl talked about while I was away from them working. Because of the mosquitoes, they tied their heads up in towels and were frightfully hot. I offered Miss Missionary some of the mosquito stuff a miner had told me of—bacon fat (it must be rancid) and turpentine. She refused—she said I looked so horrible dripping with it. She was bumped all over with bites. If you drew your hand down your face it was red with the blood the brutes had stolen from you.

I MET THEM coming over the sand, Louisa hurrying ahead to get supper, Miss Missionary limping behind, draggled and weary. Away back I saw Jimmie carrying something dreadful with long arms trailing behind in the sand, its great round body speared by the stick on Jimmie's shoulder.

"We've took the missionary's daughter hunting devilfish," chuckled Louisa, as she passed me.

We ate some of the devilfish for supper, fried in pieces like sausage. It was sweet like chicken, but very tough. Miss Missionary ate bread and jam.

"Father would not like me to eat devil," she said.

She told me the hunt was a disgusting performance. The devilfish were in the puddles around the rocks at low tide. When they saw people come, they threw their tentacles around the rocks and stuck their heads into the rocky creases; the only way to make them let go was to beat their heads in when you got the chance.

IT WAS LONG past dinnertime. Louisa could not cook because there was no water in camp. That was Jimmie's job. The spring was back in the woods, nobody but Jimmie knew where, and he was far out at sea tinkering on his boat. Louisa called and called; Jimmie heard, because his head popped up, but he would not come. Every time she called the same two Indian words.

"Make it hotter, Louisa; I want to get back to work." She called the same two words again.

"Are those words swears?"

"No, if I swore I would have to use English words."

"Why?"

"There are no swears in Haida."

"What do you say if you are angry or want to insult any-body?"

"You would say, 'Your father or your mother was a slave,' but I could not say that to Jimmie."

"Well, say something hot. I want dinner!"

She called the same two words again but her voice was different this time. Jimmie came.

Pictures of all the poles were in my sketch sack. I strapped it up and said, "That's that." The missionary's daughter revived. "Horrid place!" she said, scratching viciously at her ankle.

Then we went away from Tanoo and left the silence to heal itself—left the totem poles staring, staring out over the sea.

WHEN WE BOARDED the boat the missionary girl put her clumsy foot through my light cedar drawing-board. Nothing about her balanced—her silly little voice and her big foot; her pink and white face and big red hands. I was so mad about my board that I looked across the water for fear I'd hit her. Louisa's voice in my ear said,

"Isn't she clumsy and isn't she stupid!"

ALMOST IMMEDIATELY we were in rough water. Jimmie spread a sail in the bottom of the boat, and we women all lay flat. Nobody spoke—only groans. When the boat pitched all our bodies rolled one way and then rolled back. Under the sail where I was lying something seemed very slithery.

"Jimmie, what is under me?"

"Only the devilfish we are taking home to Mother—she likes them very much."

"Ugh!" I said. Sea-sickness on top of devilfish seemed too much.

Jimmie said, "They're dead; it won't hurt them when you roll over."

❧ SKEDANS ❧

JIMMIE, THE INDIAN, knew the jagged reefs of Skedans Bay by heart. He knew where the bobbing kelp nobs grew and that their long, hose-like tubes were waiting to strangle his propeller. Today the face of the bay was buttered over with calm and there was a wide blue sky overhead. Everything looked safe, but Jimmie knew how treacherous the bottom of Skedans Bay was; that's why he lay across the bow of his boat, anxiously peering into the water and motioning to Louisa his wife, who was at the wheel.

The engine stopped far out. There was the plop and gurgle of the anchor striking and settling and then the sigh of the little canoe being pushed over the edge of the boat, the slap as she struck the water. Jimmie got the sheep dog and me over to the beach first, so that I could get to work right away; then he went back for Louisa and the missionary's daughter.

Skedans was more open than Tanoo. The trees stood farther back from it. Behind the bay another point bit deeply into the land, so that light came in across the water from behind the village too.

There was no soil to be seen. Above the beach it was all luxuriant growth; the earth was so full of vitality that every seed which blew across her surface germinated and burst. The growing things

jumbled themselves together into a dense thicket; so tensely earnest were things about growing in Skedans that everything linked with everything else, hurrying to grow to the limit of its own capacity; weeds and weaklings alike throve in the rich moistness.

Memories came out of this place to meet the Indians; you saw remembering in their brightening eyes and heard it in the quick hushed words they said to each other in Haida. The chatter of the missionary's daughter in solemn Skedans sounded like a sheep-bell tinkling outside a church.

Skedans Beach was wide. Sea-drift was scattered over it. Behind the logs the ground sloped up a little to the old village site. It was smothered now under a green tangle, just one grey roof still squatted there among the bushes, and a battered row of totem poles circled the bay; many of them were mortuary poles, high with square fronts on top. The fronts were carved with totem designs of birds and beasts. The tops of the poles behind these carved fronts were hollowed out and the coffins stood, each in its hole on its end, the square front hiding it. Some of the old mortuary poles were broken and you saw skulls peeping out through the cracks.

To the right of Skedans were twin cones of earth and rock. They were covered to the top with trees and scrub. The land ran out beyond these mounds and met the jagged reefs of the bay.

We broke through growth above our heads to reach the house. It was of the old type, but had been repaired a little by halibut fishers who still used it occasionally. The walls were full of cracks and knot-holes. There were stones, blackened by fire, lying on the earth floor. Above them was a great smoke-hole in the roof; it had a flap that could be adjusted to the wind. Sleeping-benches ran along the wall and there was a rude table made of driftwood by the halibut fishers: Indians use the floor for their tables and seats.

When the fire roared, our blankets were spread on the platforms, and Louisa's stew-pot simmered. The place was grand—we had got close down to real things. In Skedans there were no shams.

When night came we cuddled into our blankets. The night was still. Just the waves splashed slow and even along the beach. If your face was towards the wall, the sea tang seeped in at the cracks and poured over it; if you turned round and faced in, there was the lovely smoky smell of our wood fire on the clay floor.

Early in the morning Jimmie stirred the embers; then he went out and brought us icy water from the spring to wash our faces in. He cut a little path like a green tunnel from the house to the beach, so that we could come and go easily. I went out to sketch the poles.

They were in a long straggling row the entire length of the bay and pointed this way and that; but no matter how drunken their tilt, the Haida poles never lost their dignity. They looked sadder, perhaps, when they bowed forward and more stern when they tipped back. They were bleached to a pinkish silver colour and cracked by the sun, but nothing could make them mean or poor, because the Indians had put strong thought into them and had believed sincerely in what they were trying to express.

The twisted trees and high tossed driftwood hinted that Skedans could be as thoroughly fierce as she was calm. She was downright about everything.

CUMSHEWA

TANOO, SKEDANS AND Cumshewa lie fairly close to each other on the map, yet each is quite unlike the others when you come to it. All have the West Coast wetness but Cumshewa seems always to drip, always to be blurred with mist, its foliage always to hang wet-heavy. Cumshewa rain soaked my paper, Cumshewa rain trickled among my paints.

Only one house was left in the village of Cumshewa, a large, low and desolately forsaken house that had a carefully padlocked door and gaping hole in the wall.

We spent a miserable night in this old house. Louisa's cat and the missionary's daughter always looked and acted alike when it rained. All our bones were pierced with chill. The rain spat great drops through the smoke-hole into our fire. In comfortless, damp blankets we got through the night.

In the morning Jimmie made so hot a fire that the rain splatters hissed when they dropped into it. I went out to work on the leaky beach and Jimmie rigged up a sort of shelter over my work so that the trickles ran down my neck instead of down my picture, but if I had possessed the arms and legs of a centipede they would not

have been enough to hold my things together, to defy the elements' meanness towards my canopy, materials and temper.

Through the hole in the side of the house I could hear the fretful mewings of the missionary's daughter and the cat. Indian people and the elements give and take like brothers, accommodating themselves to each others' ways without complaint. My Indians never said to me, "Hurry and get this over so that we may go home and be more comfortable." Indians are comfortable everywhere.

Not far from the house sat a great wooden raven mounted on a rather low pole; his wings were flattened to his sides. A few feet from him stuck up an empty pole. His mate had sat there but she had rotted away long ago, leaving him moss-grown, dilapidated and alone to watch dead Indian bones, for these two great birds had been set, one on either side of the doorway of a big house that had been full of dead Indians who had died during a small-pox epidemic.

Bursting growth had hidden house and bones long ago. Rain turned their dust into mud; these strong young trees were richer perhaps for that Indian dust. They grew up round the dilapidated old raven, sheltering him from the tearing winds now that he was old and rotting because the rain seeped through the moss that grew upon his back and in the hollows of his eye-sockets. The Cumshewa totem poles were dark and colourless, the wood toneless from pouring rain.

When Jimmie, Louisa, the cat and the missionary's daughter saw me squeeze back into the house through the hole and heard me say, "Done," they all jumped up. Curling the cat into her hat, Louisa set about packing; Jimmie went to prepare his boat. The cat

was peeved. She preferred Louisa's hat near the fire to the outside rain. Even the missionary's daughter showed animation as she rolled up blankets.

The memory of Cumshewa is of a great lonesomeness smothered in a blur of rain. Our boat headed for the sea. As we rounded the point Cumshewa was suddenly like something that had not quite happened.

✣ SOPHIE ✣

SOPHIE KNOCKED GENTLY on my Vancouver studio door.

"Baskets. I got baskets."

They were beautiful, made by her own people, West Coast Indian baskets. She had big ones in a cloth tied at the four corners and little ones in a flour-sack.

She had a baby slung on her back in a shawl, a girl child clinging to her skirts, and a heavy-faced boy plodding behind her.

"I have no money for baskets."

"Money no matter," said Sophie. "Old clo', 'waum' skirt—good fo' basket."

I wanted the big round one. Its price was eight dollars.

"Next month I am going to Victoria. I will bring back some clothes and get your basket."

I asked her in to rest a while and gave the youngsters bread and jam. When she tied up her baskets she left the one I coveted on the floor.

"Take it away," I said. "It will be a month before I can go to Victoria. Then I will bring clothes back with me and come to get the basket."

"You keep now. Bymby pay," said Sophie.

"Where do you live?"

"North Vancouver Mission."

"What is your name?"

"Me Sophie Frank. Everybody know me."

SOPHIE'S HOUSE WAS bare but clean. It had three rooms. Later when it got cold Sophie's Frank would cut out all the partition walls. Sophie said, "Thlee 'loom, thlee stobe. One 'loom, one stobe." The floor of the house was clean scrubbed. It was chair, table and bed for the family. There was one chair; the coal-oil lamp sat on that. Sophie pushed the babies into corners, spread my old clothes on the floor to appraise them, and was satisfied. So, having tested each other's trade-straightness, we began a long, long friendship— forty years. I have seen Sophie glad, sad, sick and drunk. I have asked her why she did this or that thing— Indian ways that I did not understand—her answer was invariably "Nice ladies always do." That was Sophie's ideal—being nice.

Every year Sophie had a new baby. Almost every year she buried one. Her little graves were dotted all over the cemetery. I never knew more than three of her twenty-one children to be alive at one time. By the time she was in her early fifties every child was dead and Sophie had cried her eyes dry. Then she took to drink.

"I GOT A new baby. I got a new baby."

Sophie, seated on the floor of her house, saw me coming through the open door and waved the papoose cradle. Two little girls rolled round on the floor; the new baby was near her in a basket-cradle. Sophie took off the cloth tented over the basket and exhibited the baby, a lean, poor thing.

Sophie herself was small and square. Her black hair sprang thick and strong on each side of the clean, straight parting and hung in twin braids across her shoulders. Her eyes were sad and heavy-lidded. Between prominent, rounded cheekbones her nose lay rather flat, broadening and snubby at the tip. Her wide upper lip pouted. It was sharp-edged, puckering over a row of poor teeth—the soothing pucker of lips trying to ease an aching tooth or to hush a crying child. She had a soft little body, a back straight as honesty itself, and the small hands and feet of an Indian.

Sophie's English was good enough, but when Frank, her husband, was there she became dumb as a plate.

"Why won't you talk before Frank, Sophie?"

"Frank he learn school English. Me, no. Frank laugh my English words."

When we were alone she chattered to me like a sparrow.

IN MAY, WHEN the village was white with cherry blossom and the blue water of Burrard Inlet crept almost to Sophie's door—just a streak of grey sand and a plank walk between—and when Vancouver city was more beautiful to look at across the water than to be in,—it was then I loved to take the ferry to the North Shore and go to Sophie's.

Behind the village stood mountains topped by the grand old "Lions", twin peaks, very white and blue. The nearer mountains were every shade of young foliage, tender grey-green, getting greener and greener till, when they were close, you saw that the village grass outgreened them all. Hens strutted their broods, papooses and pups and kittens rolled everywhere—it was good indeed to spend a day on the Reserve in spring.

Sophie and I went to see her babies' graves first. Sophie took her best plaid skirt, the one that had three rows of velvet ribbon round the hem, from a nail on the wall, and bound a yellow silk handkerchief round her head. No matter what the weather, she always wore her great shawl, clamping it down with her arms, the fringe trickling over her fingers. Sophie wore her shoes when she walked with me, if she remembered.

Across the water we could see the city. The Indian Reserve was a different world—no hurry, no business.

We walked over the twisty, up-and-down road to the cemetery. Casamin, Tommy, George, Rosie, Maria, Mary, Emily, and all the rest were there under a tangle of vines. We rambled, seeking out Sophie's graves. Some had little wooden crosses, some had stones. Two babies lay outside the cemetery fence: they had not faced life long enough for baptism.

"See! Me got stone for Rosie now."

"It looks very nice. It must have cost lots of money, Sophie."

"Grave man make cheap for me. He say, 'You got lots, lots stone from me, Sophie. Maybe bymby you get some more died baby, then you want more stone. So I make cheap for you.'"

SOPHIE'S KITCHEN WAS crammed with excited women. They had come to see Sophie's brand-new twins. Sophie was on a mattress beside the cook-stove. The twin girls were in small basket papoose cradles, woven by Sophie herself. The babies were wrapped in cotton wool which made their dark little faces look darker; they were laced into their baskets and stuck up at the edge of Sophie's mattress beside the kitchen stove. Their brown, wrinkled faces were like potatoes baked in their jackets, their hands no bigger than brown spiders.

They were thrilling, those very, very tiny babies. Everybody was excited over them. I sat down on the floor close to Sophie.

"Sophie, if the baby was a girl it was to have my name. There are two babies and I have only one name. What are we going to do about it?"

"The biggest and the best is yours," said Sophie.

My Em'ly lived three months. Sophie's Maria lived three weeks. I bought Em'ly's tombstone. Sophie bought Maria's.

SOPHIE'S "MAD" RAMPAGED inside her like a lion roaring in the breast of a dove.

"Look see," she said, holding a red and yellow handkerchief, caught together at the corners and chinking with broken glass and bits of plaster of Paris. "Bad boy bloke my glave flower! Cost five dollar one, and now boy all bloke fo' me. Bad, bad boy! You come talk me fo' p'liceman?"

At the City Hall she spread the handkerchief on the table and held half a plaster of Paris lily and a dove's tail up to the eyes of the law, while I talked.

"My mad fo' boy bloke my plitty glave flower," she said, forgetting, in her fury, to be shy of the "English words".

The big man of the law was kind. He said, "It's too bad, Sophie. What do you want me to do about it?"

"You make boy buy more this plitty kind for my glave."

"The boy has no money but I can make his old grandmother pay a little every week."

Sophie looked long at the broken pieces and shook her head.

"That ole, ole woman got no money." Sophie's anger was dying, soothed by sympathy like a child, the woman in her tender towards old Granny. "My bloke no matter for ole woman," said

Sophie, gathering up the pieces. "You scold boy big, Policeman? No make glanny pay."

"I sure will, Sophie."

THERE WAS A black skirt spread over the top of the packing case in the centre of Sophie's room. On it stood the small white coffin. A lighted candle was at the head, another at the foot. The little dead girl in the coffin held a doll in her arms. It had hardly been out of them since I had taken it to her a week before. The glassy eyes of the doll stared out of the coffin, up past the closed eyelids of the child.

Though Sophie had been through this nineteen times before, the twentieth time was no easier. Her two friends, Susan and Sara, were there by the coffin, crying for her.

The outer door opened and half a dozen women came in, their shawls drawn low across their foreheads, their faces grim. They stepped over to the coffin and looked in. Then they sat round it on the floor and began to cry, first with baby whimpers, softly, then louder, louder still—with violence and strong howling: torrents of tears burst from their eyes and rolled down their cheeks. Sophie and Sara and Susan did it too. It sounded horrible— like tortured dogs.

Suddenly they stopped. Sophie went to the bucket and got water in a tin basin. She took a towel in her hand and went to each of the guests in turn holding the basin while they washed their faces and dried them on the towel. Then the women all went out except Sophie, Sara and Susan. This crying had gone on at intervals for three days—ever since the child had died. Sophie was worn out. There had been, too, all the long weeks of Rosie's tubercular dying to go through.

"Sophie, couldn't you lie down and rest?"

She shook her head. "Nobody sleep in Injun house till dead people go to cemet'ry."

The beds had all been taken away.

"When is the funeral?"

"I dunno. Pliest go Vancouver. He not come two more day. 'Spose I got lots money he come quick. No hully up, except fo' money."

She laid her hand on the corner of the little coffin.

"See! Coffin-man think box fo' Injun baby no matter."

The seams of the cheap little coffin had burst.

AS SOPHIE AND I were coming down the village street we met an Indian woman whom I did not know. She nodded to Sophie, looked at me and half paused. Sophie's mouth was set, her bare feet pattered quick, hurrying me past the woman.

"Go church house now?" she asked me.

The Catholic church had twin towers. Wide steps led up to the front door which was always open. Inside it was bright, in a misty way, and still except for the wind and sea-echoes. The windows were gay coloured glass; when you knelt the wooden footstools and pews creaked. Hush lurked in every corner. The smell of the church seemed fusty after the fresh sea air outside, the paper flowers artificial.

The rope of the bell dangled dead in the entrance. It was a new rope and smelt of tar. Paper flowers stood stiffly before the Virgin. Always a few candles burned. Everything but those flickers of flame was stone-still.

When we came out of the church we sat on the steps for a little. I said, "Who was that woman we met, Sophie?"

"Mrs. Chief Joe Capilano."

"Oh! I would like to know Mrs. Chief Joe Capilano. Why did you hurry by so quick? She wanted to stop."

"I don' want you know Mrs. Chief Joe."

"Why?"

"You fliend for me, not fliend for her."

"My heart has room for more than one friend, Sophie."

"You fliend for me, I not want Mrs. Chief Joe get you."

"You are always my first and best friend, Sophie." She hung her head, her mouth obstinate. We went to Sara's house.

Sara was Sophie's aunt, a wizened bit of a woman whose eyes, nose, mouth and wrinkles were all twisted to the perpetual expressing of pain. Once she had had a merry heart, but pain had trampled out the merriness. She lay on a bed draped with hangings of clean, white rags dangling from poles. The wall behind her bed, too, was padded heavily with newspaper to keep draughts off her "Lumatiz".

"Hello, Sara. How are you?"

"Em'ly! Sophie's Em'ly!"

The pain wrinkles scuttled off to make way for Sara's smile, but hurried back to twist for her pain.

"I dunno what for I got Lumatiz, Em'ly. I dunno. I dunno."

Everything perplexed poor Sara. Her merry heart and tortured body were always at odds. She drew a humped wrist across her nose and said, "I dunno, I dunno," after each remark.

"Goodbye, Sophie's Em'ly; come some more soon. I like that you come. I dunno why I got pain, lots pain. I dunno—I dunno."

I said to Sophie, "You see! The others know I am your big friend. They call me 'Sophie's Em'ly'."

She was happy.

SUSAN LIVED ON one side of Sophie's house and Mrs. Johnson, the Indian widow of a white man, on the other. The widow's house was beyond words clean. The cook-stove was a mirror, the floor white as a sheet from scrubbing. Mrs. Johnson's hands were clever and busy. The row of hard kitchen chairs had each its own antimacassar and cushion. The crocheted bedspread and embroidered pillow-slips, all the work of Mrs. Johnson's hands, were smoothed taut. Mrs. Johnson's husband had been a sea captain. She had loved him deeply and remained a widow though she had had many offers of marriage after he died. Once the Indian Agent came, and said:

"Mrs. Johnson, there is a good man who has a farm and money in the bank. He is shy, so he sent me to ask if you will marry him."

"Tell that good man, 'Thank you,' Mr. Agent, but tell him, too, that Mrs. Johnson only got love for her dead Johnson."

Sophie's other neighbour, Susan, produced and buried babies almost as fast as Sophie herself. The two women laughed for each other and cried for each other. With babies on their backs and baskets on their arms they crossed over on the ferry to Vancouver and sold their baskets from door to door. When they came to my studio they rested and drank tea with me. My parrot, sheep dog, the white rats and the totem pole pictures all interested them. "An' you got Injun flower, too," said Susan.

"Indian flowers?"

She pointed to ferns and wild things I had brought in from the woods.

SOPHIE'S HOUSE WAS shut up. There was a chain and padlock on the gate. I went to Susan.

"Where is Sophie?"

"Sophie in sick house. Got sick eye."

I went to the hospital. The little Indian ward had four beds. I took ice cream and the nurse divided it into four portions.

A homesick little Indian girl cried in the bed in one corner, an old woman grumbled in another. In a third there was a young mother with a baby, and in the fourth bed was Sophie.

There were flowers. The room was bright. It seemed to me that the four brown faces on the four white pillows should be happier and far more comfortable here than lying on mattresses on the hard floors in the village, with all the family muddle going on about them.

"How nice it is here, Sophie."

"Not much good of hospital, Em'ly."

"Oh! What is the matter with it?"

"Bad bed."

"What is wrong with the beds?"

"Move, move, all time shake. 'Spose me move, bed move too."

She rolled herself to show how the springs worked. "Me ole-fashion, Em'ly. Me like kitchen floor fo' sick."

SUSAN AND SOPHIE were in my kitchen, rocking their sorrows back and forth and alternately wagging their heads and giggling with shut eyes at some small joke.

"You go live Victoria now, Em'ly," wailed Sophie, "and we never see those babies, never!"

Neither woman had a baby on her back these days. But each had a little new grave in the cemetery. I had told them about a friend's twin babies. I went to the telephone.

"Mrs. Dingle, you said I might bring Sophie to see the twins?"

"Surely, any time," came the ready reply.

"Come, Sophie and Susan, we can go and see the babies now."

The mothers of all those little cemetery mounds stood look-
ing and looking at the thriving white babies, kicking and
sprawling on their bed. The women said, "Oh my!—Oh my!"
over and over.

Susan's hand crept from beneath her shawl to touch a baby's
leg. Sophie's hand shot out and slapped Susan's.

The mother of the babies said, "It's all right, Susan; you may
touch my baby."

Sophie's eyes burned Susan for daring to do what she so
longed to do herself. She folded her hands resolutely under her
shawl and whispered to me,

"Nice ladies don' touch, Em'ly."

❧ D'SONOQUA ❧

I WAS SKETCHING in a remote Indian village when I first saw her. The village was one of those that the Indians use only for a few months in each year; the rest of the time it stands empty and desolate. I went there in one of its empty times, in a drizzling dusk.

When the Indian Agent dumped me on the beach in front of the village, he said "There is not a soul here. I will come back for you in two days." Then he went away.

I had a small griffon dog with me, and also a little Indian girl, who, when she saw the boat go away, clung to my sleeve and wailed, "I'm 'fraid."

We went up to the old deserted mission house. At the sound of the key in the rusty lock, rats scuttled away. The stove was broken, the wood wet. I had forgotten to bring candles. We spread our blankets on the floor, and spent a poor night. Perhaps my lack of sleep played its part in the shock that I got, when I saw her for the first time.

Water was in the air, half mist, half rain. The stinging nettles, higher than my head, left their nervy smart on my ears and forehead, as I beat my way through them, trying all the while to keep

my feet on the plank walk which they hid. Big yellow slugs crawled on the walk and slimed it. My feet slipped, and I shot headlong to her very base, for she had no feet. The nettles that were above my head reached only to her knee.

It was not the fall alone that jerked the "Oh's" out of me, for the great wooden image towering above me was indeed terrifying.

The nettle-bed ended a few yards beyond her, and then a rocky bluff jutted out, with waves battering it below. I scrambled up and went out on the bluff, so that I could see the creature above the nettles. The forest was behind her, the sea in front.

Her head and trunk were carved out of, or rather into, the bole of a great red cedar. She seemed to be part of the tree itself, as if she had grown there at its heart, and the carver had only chipped away the outer wood so that you could see her. Her arms were spliced and socketed to the trunk, and were flung wide in a circling, compelling movement. Her breasts were two eagle heads, fiercely carved. That much, and the column of her great neck, and her strong chin, I had seen when I slithered to the ground beneath her. Now I saw her face.

The eyes were two rounds of black, set in wider rounds of white, and placed in deep sockets under wide, black eyebrows. Their fixed stare bored into me as if the very life of the old cedar looked out, and it seemed that the voice of the tree itself might have burst from that great round cavity, with projecting lips, that was her mouth. Her ears were round, and stuck out to catch all sounds. The salt air had not dimmed the heavy red of her trunk and arms and thighs. Her hands were black, with blunt finger-tips painted a dazzling white. I stood looking at her for a long, long time.

The rain stopped, and white mist came up from the sea, gradually paling her back into the forest. It was as if she belonged there,

and the mist were carrying her home. Presently the mist took the forest too, and, wrapping them both together, hid them away.

"Who is that image?" I asked the little Indian girl, when I got back to the house.

She knew which one I meant, but to gain time, she said, "What image?"

"The terrible one, out there on the bluff." The girl had been to Mission School, and fear of the old, fear of the new, struggled in her eyes. "I dunno," she lied.

I never went to that village again, but the fierce wooden image often came to me, both in my waking and in my sleeping.

SEVERAL YEARS PASSED, and I was once more sketching in an Indian village. There were Indians in this village, and in a mild backward way it was "going modern". That is, the Indians had pushed the forest back a little to let the sun touch the new buildings that were replacing the old community houses. Small houses, primitive enough to a white man's thinking, pushed here and there between the old. Where some of the big community houses had been torn down, for the sake of the lumber, the great corner posts and massive roof-beams of the old structure were often left, standing naked against the sky, and the new little house was built inside, on the spot where the old one had been.

It was in one of these empty skeletons that I found her again. She had once been a supporting post for the great centre beam. Her pole-mate, representing the Raven, stood opposite her, but the beam that had rested on their heads was gone. The two poles faced in, and one judged the great size of the house by the distance between them. The corner posts were still in place, and the

earth floor, once beaten to the hardness of rock by naked feet, was carpeted now with rich lush grass.

I knew her by the stuck-out ears, shouting mouth, and deep eye-sockets. These sockets had no eye-balls, but were empty holes, filled with stare. The stare, though not so fierce as that of the former image, was more intense. The whole figure expressed power, weight, domination, rather than ferocity. Her feet were planted heavily on the head of the squatting bear, carved beneath them. A man could have sat on either huge shoulder. She was unpainted, weather-worn, sun-cracked, and the arms and hands seemed to hang loosely. The fingers were thrust into the carven mouths of two human heads, held crowns down. From behind, the sun made unfathomable shadows in eye, cheek and mouth. Horror tumbled out of them.

I saw Indian Tom on the beach, and went to him.

"Who is she?"

The Indian's eyes, coming slowly from across the sea, followed my pointing finger. Resentment showed in his face, greeny-brown and wrinkled like a baked apple,—resentment that white folks should pry into matters wholly Indian.

"Who is that big carved woman?" I repeated.

"D'Sonoqua." No white tongue could have fondled the name as he did.

"Who is D'Sonoqua?"

"She is the wild woman of the woods."

"What does she do?"

"She steals children."

"To eat them?"

"No, she carries them to her caves; that," pointing to a purple scar on the mountain across the bay, "is one of her caves. When

she cries 'OO-oo-oo-oeo', Indian mothers are too frightened to move. They stand like trees, and the children go with D'Sonoqua."

"Then she is bad?"

"Sometimes bad...sometimes good," Tom replied, glancing furtively at those stuck-out ears. Then he got up and walked away.

I went back, and, sitting in front of the image, gave stare for stare. But her stare so over-powered mine, that I could scarcely wrench my eyes away from the clutch of those empty sockets. The power that I felt was not in the thing itself, but in some tremendous force behind it, that the carver had believed in.

A shadow passed across her hands and their gruesome holdings. A little bird, with its beak full of nesting material, flew into the cavity of her mouth, right in the pathway of that terrible OO-oo-oo-oeo. Then my eye caught something that I had missed—a tabby cat asleep between her feet.

This was D'Sonoqua, and she was a supernatural being, who belonged to these Indians.

"Of course," I said to myself, "I do not believe in supernatural beings. Still—who understands the mysteries behind the forest? What would one do if one did meet a supernatural being?" Half of me wished that I could meet her, and half of me hoped I would not.

Chug—chug—the little boat had come into the bay to take me to another village, more lonely and deserted than this. Who knew what I should see there? But soon supernatural beings went clean out of my mind, because I was wholly absorbed in being naturally seasick.

WHEN YOU HAVE been tossed and wracked and chilled, any wharf looks good, even a rickety one, with its crooked legs stockinged in barnacles. Our boat nosed under its clammy darkness, and I

crawled up the straight slimy ladder, wondering which was worse, natural sea-sickness, or supernatural "creeps". The trees crowded to the very edge of the water, and the outer ones, hanging over it, shadowed the shoreline into a velvet smudge. D'Sonoqua might walk in places like this. I sat for a long time on the damp, dusky beach, waiting for the stage. One by one dots of light popped from the scattered cabins, and made the dark seem darker. Finally the stage came.

We drove through the forest over a long straight road, with black pine trees marching on both sides. When we came to the wharf the little gas mail-boat was waiting for us. Smell and blurred light oozed thickly out of the engine room, and except for one lantern on the wharf everything else was dark. Clutching my little dog, I sat on the mail sacks which had been tossed onto the deck.

The ropes were loosed, and we slid out into the oily black water. The moon that had gone with us through the forest was away now. Black pine-covered mountains jagged up on both sides of the inlet like teeth. Every gasp of the engine shook us like a great sob. There was no rail round the deck, and the edge of the boat lay level with the black slithering horror below. It was like being swallowed again and again by some terrible monster, but never going down. As we slid through the water, hour after hour, I found myself listening for the OO-oo-oo-oeo.

Midnight brought us to a knob of land, lapped by the water on three sides, with the forest threatening to gobble it up on the fourth. There was a rude landing, a rooming-house, an eating-place, and a store, all for the convenience of fishermen and loggers. I was given a room, but after I had blown out my candle, the stillness and the darkness would not let me sleep.

In the brilliant sparkle of the morning when everything that was not superlatively blue was superlatively green, I dickered

with a man who was taking a party up the inlet that he should drop me off at the village I was headed for.

"But," he protested, "there is nobody there."

To myself I said, "There is D'Sonoqua."

From the shore, as we rowed to it, came a thin feminine cry— the mewing of a cat. The keel of the boat had barely grated in the pebbles, when the cat sprang aboard, passed the man shipping his oars, and crouched for a spring into my lap. Leaning forward, the man seized the creature roughly, and with a cry of "Dirty Indian vermin!" flung her out into the sea.

I jumped ashore, refusing his help, and with a curt "Call for me at sun-down," strode up the beach; the cat followed me.

When we had crossed the beach and come to a steep bank, the cat ran ahead. Then I saw that she was no lean, ill-favoured Indian cat, but a sleek aristocratic Persian. My snobbish little griffon dog, who usually refused to let an Indian cat come near me, surprised me by trudging beside her in comradely fashion.

THE VILLAGE WAS typical of the villages of these Indians. It had only one street, and that had only one side, because all the houses faced the beach. The two community houses were very old, dilapidated and bleached, and the handful of other shanties seemed never to have been young; they had grown so old before they were finished, that it was then not worth while finishing them.

Rusty padlocks carefully protected the gaping walls. There was the usual broad plank in front of the houses, the general sitting and sunning place for Indians. Little streams ran under it, and weeds poked up through every crack, half hiding the companies

of tins, kettles, and rags, which patiently waited for the next gale and their next move.

In front of the Chief's house was a high, carved totem pole, surmounted by a large wooden eagle. Storms had robbed him of both wings, and his head had a resentful twist, as if he blamed somebody. The heavy wooden heads of two squatting bears peered over the nettle-tops. The windows were too high for peeping in or out. "But, save D'Sonoqua, who is there to peep?" I said aloud, just to break the silence. A fierce sun burned down as if it wanted to expose every ugliness and forlornness. It drew the noxious smell out of the skunk cabbages, growing in the rich black ooze of the stream, scummed the water-barrels with green slime, and branded the desolation into my very soul.

The cat kept very close, rubbing and bumping itself and purring ecstatically; and although I had not seen them come, two more cats had joined us. When I sat down they curled into my lap, and then the strangeness of the place did not bite into me so deeply. I got up, determined to look behind the houses.

Nettles grew in the narrow spaces between the houses. I beat them down, and made my way over the bruised dank-smelling mass into a space of low jungle.

Long ago the trees had been felled and left lying. Young forest had burst through the slash, making an impregnable barrier, and sealing up the secrets which lay behind it. An eagle flew out of the forest, circled the village, and flew back again.

Once again I broke silence, calling after him, "Tell D'Sonoqua—" and turning, saw her close, towering above me in the jungle.

Like the D'Sonoqua of the other villages she was carved into the bole of a red cedar tree. Sun and storm had bleached the wood,

moss here and there softened the crudeness of the modelling; sincerity underlay every stroke.

She appeared to be neither wooden nor stationary, but a singing spirit, young and fresh, passing through the jungle. No violence coarsened her; no power domineered to wither her. She was graciously feminine. Across her forehead her creator had fashioned the Sistheutl, or mythical two-headed sea-serpent. One of its heads fell to either shoulder, hiding the stuck-out ears, and framing her face from a central parting on her forehead which seemed to increase its womanliness.

She caught your breath, this D'Sonoqua, alive in the dead bole of the cedar. She summed up the depth and charm of the whole forest, driving away its menace.

I sat down to sketch. What was the noise of purring and rubbing going on about my feet? Cats. I rubbed my eyes to make sure I was seeing right, and counted a dozen of them. They jumped into my lap and sprang to my shoulders. They were real—and very feminine.

There we were—D'Sonoqua, the cats and I—the woman who only a few moments ago had forced herself to come behind the houses in trembling fear of the "wild woman of the woods"— wild in the sense that forest-creatures are wild—shy, untouchable.

❧ THE BLOUSE ❧

THE SOUND OF waves came in at the open door; the smell of the sea and of the sun-warmed earth came in too. It was expected that very soon death would enter. A row of women sat outside the hut—they were waiting to mourn and howl when death came.

The huddle of bones and withered skin on the mattress inside the hut knew death was coming. Although the woman was childless and had no husband, she knew that the women of her tribe would make sorrow-noise for her when death came.

The eyes of the dying woman were glassy and half closed. I knelt beside her and put my hand over her cold bony one. My blouse touched her and she opened her eyes wide. Turning her hand, she feebly clutched the silk of my sleeve.

"Is there something you want, Mary?"

"Good," she whispered, still clutching the sleeve.

I thought that she was dead, holding my sleeve in a death grip. One of the women came in and tried to free me. Mary's eyes opened and she spoke in Indian.

"Mary wants your blouse," said the stooping woman to me.

"Wants my blouse?"

"Uh huh—wants for grave."

"To be buried in?"

"No, for grave-house."

I understood. Mary had not many things now but she had been important once. They would build a little wooden room with a show window in it over her grave. Here they would display her few poor possessions, the few hoarded trifles of her strong days. My blouse would be an addition.

The dying woman's eyes were on my face.

I scrambled out of the blouse and into my jacket. I laid the blouse across Mary. She died with her hands upon it.

✂ THE STARE ✂

MILLIE'S STARE WAS the biggest thing in the hut. It dimmed for a moment as we stood in its way—but in us it had no interest. The moment we moved from its path it tightened again—this tense, living stare glowing in the sunken eyes of a sick Indian child.

All the life that remained in the emaciated, shrivelled little creature was concentrated in that stare. It burned a path for itself right across the sea to the horizon, burning with longing focused upon the return of her father's whaling-boat.

The missionary bent over the child.

"Millie!"

Millie's eyes lifted grudgingly, then hastened back to their watching.

Turning to the old crone who took the place of a mother who was dead and cared for the little girl, the missionary asked, "How is she, Granny?"

"I t'ink 'spose boat no come quick, Milly die plitty soon now."

"Is there no word of the boats?"

"No, maybe all Injun-man dead. Whale fishin' heap, heap bad for make die."

They brought the child food. She struggled to force down enough to keep the life in her till her father came. Squatted on her mat on the earth floor, her chin resting on the sharp knees and circled by her sticks of arms, she sat from dawn till dark, watching. When light was gone the stare fought its way, helped by Millie's ears, listening, listening out into black night.

IT WAS IN the early morning that the whaling-boats came home. When the mist lifted, Millie saw eight specks out on the horizon. Taut, motionless, uttering no word, she watched them grow.

"The boats are coming!" The cry rang through the village. Women left their bannock-baking, their basket-weaving and hurried to the shore. The old crone who tended Millie hobbled to the beach with the rest.

"The boats are coming!" Old men warming their stiff bodies in the sun shaded dull eyes with their hands to look far out to sea, groaning for joy that their sons were safe.

"The boats are coming!" Quick ears of children heard the cry in the schoolhouse and, squeezing from their desks without leave, pattered down to the shore. The missionary followed. It was the event of the year, this return of the whaling-boats.

Millie's father was the first to land. His eyes searched among the people.

"My child?"

His feet followed the women's pointing fingers. Racing up the bank, his bulk filled the doorway of the hut. The stare enveloped him, Millie swayed towards him. Her arms fell down. The heavy plaits of her hair swung forward. Brittle with long watching, the stare had snapped.

❧ GREENVILLE ❧

THE CANNERY BOSS said, "Try Sam; he has a gas boat and comes from Greenville. That's Sam over there—the Indian in the striped shirt."

I came close to where Sam was forking salmon from the scow onto the cannery chutes.

"Sam, I want to go to Greenville. Could you take me there on Sunday?"

"Uh huh."

"What time Sunday?"

"Eight o'clock."

On Sunday morning I sat on the wharf from eight o'clock till noon. Sam's gas boat was down below. There was a yellow tarpaulin tented across her middle. Four bare feet stuck out at one end and two black heads at the other.

From stir to start it took the Indians four hours. Sam and his son sauntered up and down getting things as if time did not exist. Round noon the gas boat's impudent sputter ticked out across the wide face of the Naas River.

The Indian and his son were silent travellers.

I had a small griffon dog who sat at my feet quivering and alert. I felt like an open piano that any of the elements could strum on.

The great Naas swept grandly along. The nameless little river that Greenville was on emptied into the Naas. When our boat turned from the great into the little river she had no more ambition. Her engine died after a few puffs. Then we drifted a short way and nosed alongside a crude plank landing. This was Greenville.

It was between lights, neither day nor dark.

Five or six shadows came limping down the bank to the landing—Indian dogs—gaunt forsaken creatures. They knew when they heard the engine it meant man. The dogs looked queer.

"What is the matter with the dogs?"

"Porkpine," grunted the Indian.

The creatures' faces were swollen into wrong shapes. Porcupine quills festered in the swellings.

"Why don't the Indians take their dogs with them and not leave them to starve or hunt porcupine?"

"Cannery Boss say no can."

When I went towards the dogs they backed away growling.

"Him hiyu fierce," warned the Indian.

In the dusk with the bedding and bundles on their shoulders the two Indians looked monstrous moving up the bank ahead of me.

I held my dog tight because of the fierceness of those skulking shadow-dogs following us.

Greenville was a large village, low and flat. Its stagnant swamps and ditches were glory places for the mosquitoes to breed in. Only the hum of the miserable creatures stirred the heavy murk that beaded our foreheads with sweat as we pushed our way through it.

Half-built, unpainted houses, old before ever they were finished, sat hunched irregularly along the grass-grown way. Planks on

spindly trestles bridged the scummed sloughs. Emptiness glared from windows and shouted up dead chimneys, weighted emptiness, that crushed the breath back into your lungs and chilled the heart in your sweating body.

Stumbling over stones and hummocks I hurried after the men who were anxious to place me and be gone down the Naas to the cannery again.

I asked the Indian, "Is there no one in this village?"

"One ole man, one woman, and one baby stop. Everybody go cannery."

"Where can I stay?"

"Teacher's house good for you."

"Where is the teacher?"

"Teacher gone too."

WE WERE AWAY from the village street now and making our way through bracken breast high. The schoolhouse was among it crouched on the edge of the woods. It was schoolhouse and living quarters combined. Trees pressed it close; undergrowth surged up over its windows.

The Indian unlocked the door, pushed us in and slammed the door to violently, as if something terrible were behind us.

"What was it you shut out, Sam?"

"Mosquitoe."

In here the hum of the mosquitoes had stopped, as every other thing had stopped in the murky grey of this dreadful place, clock, calendar, even the air—the match the Indian struck refused to live.

We felt our way through the long schoolroom to a room behind that was darker still. It had a drawn blind and every crevice was sealed. The air in it felt as solid as the table and the stove. You

chewed rather than breathed it. It tasted of coal-oil after we lit the lamp.

I opened a door into the shed. The pungent smell of cut stove-wood that came in was good.

The Indians were leaving me.

"Stop! The old man and the woman, where are they? Show me."

Before I went I opened all the doors. Mosquitoes were better than this strangling deadness, and I never could come back alone and open the door of the big dark room. Then I ran through the bracken and caught up with the Indians.

They led me to the farthest house in the village. It was cut off from the schoolhouse by space filled with desperate loneliness.

THE OLD MAN was on the floor; he looked like a shrivelled old bird there on his mattress, caged about with mosquito netting. He had lumbago. His wife and grandchild were there too.

The womanliness of the old squaw stayed by me when I came back. All night long I was glad of that woman in Greenville.

It was dark when I got back to the school and the air was oozing sluggishly through the room.

I felt like a thief taking possession of another's things without leave. The school teacher had left everything shipshape. Everything told the type of woman she was.

Soon I made smoke roll round inside the stove and a tiny flame wavered. I turned forward the almanac sheets and set the clock ticking. When the kettle sang things had begun to live.

The night was long and black. As dawn came I watched things slowly poke out of the black. Each thing was a surprise.

The nights afterwards in this place were not bad like the first one, because I then had my bearings. All my senses had touched

the objects about me. But it was lying in that smothering dark and not knowing what was near me—what I might touch if I reached out a hand—that made the first night so horrible.

When I opened the schoolhouse door in the morning the village dogs were in the bracken watching. They went frantic over the biscuits I threw to them. A black one came crouching. She let me pull the porcupine quills out of her face. When the others saw her fear dry up, they came closer too. It was people they wanted even more than food. Wherever I went about the village they followed me.

IN THE SWAMPY places and ditches of Greenville skunk cabbages grew—gold and brimming with rank smell—hypocrites of loveliness peeping from the lush green of their great leaves. The smell of them was sickening.

I looked through the blindless windows of the Indian houses. Half-eaten meals littered the tables. Because the tide had been right to go, bedding had been stripped from the springs, food left about, water left unemptied to rust the kettles. Indians slip in and out of their places like animals. Tides and seasons are the things that rule their lives: domestic arrangements are mere incidentals.

The houses looked as if they had been shaken out of a dice box onto the land and stayed just where they lit. The elements dominated them from the start. As soon as a few boards were put together the family moved in, and the house went on building around them until some new interest came along. Then the Indian dropped his tools. If you asked when he was going to finish building his house he said, "Nodder day—me too busy now," and after a long pull on his pipe he would probably lie round in the sun for days doing nothing.

I WENT OFTEN to the last house in the village to gossip with the woman. She was not as old as you thought at first, but very weather-beaten. She was a friendly soul, but she spoke no English. We conversed like this,—one would point at something, the other clap her hands and laugh, or moan and shake her head as was right. Our eyebrows worked too and our shoulders and heads. A great deal of fun and information passed back and forth between us.

Ginger Pop, my griffon, was a joy to Grannie. With a chuckle that wobbled the fat all over her, she would plant her finger on the snub of her own broad nose and wrinkle it back towards her forehead in imitation of the dog's snub, and laugh till the tears poured out of her eyes. All the while the black eyes of her solemn grandchild stared.

Grannie also enjoyed my duck "pantalettes" that came below my skirts to the soles of my shoes, my duplicate pairs of gloves, and the cheese-cloth veil with a glass window in front. This was my mosquito armour. Hers consisted of pair upon pair of heavy wool stockings handknitted, and worn layer upon layer till they were deeper than the probes of the mosquitoes, and her legs looked like barrels.

The old man and I had a few Chinook words in common. I went sometimes to the darkened shed where he was building a boat. He kept a smudge and the air was stifling. Tears and sweat ran down our faces. He wiped his face with the bandana floating under his hat brim to protect his neck and blew at the mosquitoes and rubbed his lumbago. Suddenly his eye would catch the comic face of Ginger Pop and he too would throw down his tools and give himself up to mirth at the pup's expense. When he laughed, that was the time to ask him things.

"I am sorry that there are no totem poles in Greenville. I like totem poles," I said.

"Halo totem stick kopa Greenville."

"Old village with totem poles stop up the Naas?"

"Uh huh."

"I would like to see them."

"Uh huh."

"Will you take me in your boat?"

"Uh huh, Halo tillicum kopet."

"I want to see the poles, not people. You take me tomorrow?"

"Uh huh."

So we went to Gittex and Angedar, two old village-sites on the Naas River. His old boat crept through the side-wash meanderings of the Naas. Suddenly we came out onto its turbulent waters and shot across them: and there, tipping drunkenly over the top of dense growth, were the totem poles of Gittex. They looked like mere sticks in the vast sea of green that had swallowed the old village. Once they, too, had been forest trees, till the Indian mutilated and turned them into bare poles. Then he enriched the shorn things with carvings. He wanted some way of showing people things that were in his mind, things about the creatures and about himself and their relation to each other. He cut forms to fit the thoughts that the birds and animals and fish suggested to him, and to these he added something of himself. When they were all linked together they made very strong talk for the people. He grafted this new language onto the great cedar trunks and called them Totem poles and stuck them up in the villages with great ceremony. Then the cedar and the creatures and the man all talked together through the totem poles to the people. The carver did even more—he let his imaginings rise above the objects that he saw and pictured supernatural beings too.

The creatures that had flesh and blood like themselves the Indians understood. They accepted them as their ancestors but the supernatural things they feared and tried to propitiate.

Every clan took a creature for its particular crest. Individuals had private crests too, which they earned for themselves often by privation and torture and fasting. These totem creatures were believed to help specially those who were of their crest.

When you looked at a man's pole, his crests told you who he was, whom he might marry and whom he might not marry—for people of the same crest were forbidden to marry each other.

You knew also by the totem what sort of man he was or at least what he should be because men tried to be like the creature of their crest, fierce, or brave, or wise, or strong.

Then the missionaries came and told the Indians this was all foolish and heathenish. They took the Indians away from their old villages and the totem poles and put them into new places where life was easier, where they bought things from a store instead of taking them from nature.

Greenville, which the Indians called "Lakalzap", was one of these new villages. They took no totem poles with them to hamper their progress in new ways; the poles were left standing in the old places. But now there was no one to listen to their talk any more. By and by they would rot and topple to the earth, unless white men came and carried them away to museums. There they would be labelled as exhibits, dumb before the crowds who gaped and laughed and said, "This is the distorted foolishness of an uncivilized people." And the poor poles could not talk back because the white man did not understand their language.

At Gittex there was a wooden bear on top of such a high pole he was able still to look over the top of the woods. He was a joke

of a bear—every bit of him was merry. He had one paw up against his face, he bent forward and his feet clung to the pole. I tried to circle about so that I could see his face but the monstrous tangle was impossible to break through.

I did beat my way to the base of another pole only to find myself drowned under an avalanche of growth sweeping down the valley. The dog and I were alone in it—just nothings in the overwhelming immensity.

My Indian had gone out to mid-river. It seemed an awful thing to shatter that silence with a shout, but I was hungry and I dared not raise my veil till I got far out on the Naas. Mosquitoes would have filled my mouth.

AFTER SEVEN DAYS the Indians came back with their boat and took me down the Naas again.

I left the old man and woman leisurely busy, the woman at her wash-tub and the man in his stifling boat-house. Each gave me a passing grin and a nod when I said goodbye: comings and goings are as ordinary to Indians as breathing.

I let the clock run down. Flapped the leaves of the calendar back, and shut the Greenville schoolhouse tight.

The dogs followed to the edge of the water, their stomachs and hearts sore at seeing us go. Perhaps in a way dogs are more domestic and more responsive than Indians.

❈ TWO BITS *and a* WHEEL-BARROW ❈

THE SMALLEST COIN we had in Canada in early days was a dime, worth ten cents. The Indians called this coin "a Bit". Our next coin, double in buying power and in size, was a twenty-five cent piece and this the Indians called "Two Bits".

Two bits was the top price that Old Jenny knew. She asked two bits for everything she had to sell, were it canoe-bailer, eagle's wing, cedar-bark basket or woven mat. She priced each at "two bits" and if I had said, "How much for your husband or your cat?" she would have answered "two bits" just the same.

Her old husband did not look worth two bits. He was blind and very moth-eaten. All day he lay upon a heap of rags in the corner of their hut. He was quite blind but he had some strength still. Jenny made him lie there except when he was led, because he fell into the fire or into the big iron cook-pot and burned himself if he went alone. There was such a litter over the floor that he could not help tripping on something if he took even a step. So Jenny-Two-Bits ordered her old blind Tom to stay in his corner till she was ready. Jenny was getting feeble. She was lame in the hip and walked with a crooked stick that she had pulled from the sea.

Tommy knew that day had come when he felt Jenny-Two-Bits' stick jab him. The stick stayed in the jab until Tom took hold. Then still holding the stick Jenny steered him across to where she lay. When he came close she pulled herself up by hanging onto his clothes. When bits of his old rags tore off in her hands she scolded Tom bitterly for having such poor, weak clothes.

Tom could tell by the cold clammy feel how very new the morning was when Jenny pushed him out of the door and told him to stand by the wall and not move while she went for the wheel-barrow. It screeched down the alley. Jenny backed Tom between the handles and he took hold of them. Then she tied a rope to each of his arms above the elbow. She used the ropes for reins and hobbled along, slapping the barrow with her stick to make Tom go and poking her stick into his back to make him stop. At that early hour the village was empty. They always tried to be the first on the beach so that they could have the pick of what the sea had thrown up.

They went slowly to the far end of the village street where the bank was low and here they left the barrow.

Jenny-Two-Bits led Tom along the quiet shore. She peered this way and that to see what the waves had brought in. Sometimes the sea gave them good things, sometimes nothing at all, but there were always bits of firewood and bark to be had if they got there before anyone else.

The old woman's eyes were very sharp and the wheel-barrow hardly ever came back empty. When Jenny found anything worthwhile, first she peered, then she beat it with her stick and took Tom's hand and laid it on the wet cast-up thing. Tom would lift it and carry it to the barrow. Then they came back to their shanty and sat down in the sun outside the door to rest.

Sometimes Jenny and Tom went in a canoe to fish out in the bay. Tom held the lines, Jenny paddled.

When they caught a fish or when Jenny sold something for two bits or when they sat together baking themselves in the sunshine, they were happy enough.

✖ SLEEP ✖

WHEN I WAS a child I was staying at one of Victoria's beaches.

I was down on the point watching a school of porpoises at play off Trial Island when a canoe came round the headland. She was steering straight for our beach.

The Government allowed the Indians to use the beaches when they were travelling, so they made camp and slept wherever the night happened to fall.

In the canoe were a man and woman, half a dozen children, a dog, a cat and a coop of fowls, besides all the Indians' things. She was a West Coast canoe—dug out of a great red cedar tree. She was long and slim, with a high prow shaped like a wolf's head. She was painted black with a line of blue running round the top of the inside. Her stern went straight down into the water. The Indian mother sat in the stern and steered the canoe with a paddle.

When the canoe was near the shore, the man and the woman drove their paddles strong and hard, and the canoe shot high up onto the pebbles with a growling sound. The barefoot children swarmed over her side and waded ashore.

The man and the woman got out and dragged the canoe high onto the beach. There was a baby tucked into the woman's shawl;

the shawl bound the child close to her body. She waddled slowly across the beach, her bare feet settling in the sand with every step, her fleshy body squared down on to her feet. All the movements of the man and the woman were slow and steady; their springless feet padded flatly; their backs and shoulders were straight. The few words they said to each other were guttural and low-pitched.

The Indian children did not race up and down the beach, astonished at strange new things, as we always were. These children belonged to the beach, and were as much a part of it as the drift-logs and the stones.

The man gathered a handful of sticks and lit a fire. They took a big iron pot and their food out of the canoe, and set them by the fire. The woman sat among the things with her baby—she managed the shawl and the baby so that she had her arms free, and her hands moved among the kettles and food.

The man and a boy, about as big as I was, came up the path on the bank with tin pails. When they saw me, the boy hung back and stared. The man grinned and pointed to our well. He had coarse hair hanging to his shoulders; it was unbrushed and his head was bound with a red band. He had wrinkles everywhere, face, hands and clothing. His coat and pants were in tatters. He was brown and dirty all over, but his face was gentle and kind.

Soon I heard the pad-pad of their naked feet on the clay of the path. The water from the boy's pail slopped in the dust while he stared back at me.

They made tea and ate stuff out of the iron pot; it was fish, I could smell it. The man and the woman sat beside the pot, but the children took pieces and ran up and down eating them.

They had hung a tent from the limb of the old willow tree that lolled over the sand from the bank. The bundles and blankets

had been tossed into the tent; the flaps were open and I could see everything lying higgledy-piggledy inside.

Each child ate what he wanted; then he went into the tent and tumbled, dead with sleep, among the bundles. The man, too, stopped eating and went into the tent and lay down. The dog and the cat were curled up among the blankets.

The woman on the beach drew the smouldering logs apart; when she poured a little water on them they hissed. Last of all she too went into the tent with her baby.

The tent full of sleep greyed itself into the shadow under the willow tree. The wolf's head of the canoe stuck up black on the beach a little longer; then it faded back and back into the night. The sea kept on going slap-slap-slap over the beach.

❧ SAILING *to* YAN ❧

AT THE APPOINTED time I sat on the beach waiting for the Indian. He did not come and there was no sign of his boat.

An Indian woman came down the bank carrying a heavy not-walking-age child. A slim girl of twelve was with her. She carried a paddle and going to a light canoe that was high on the sand, she began to drag it towards the sea.

The woman put the baby into the canoe and she and the girl grunted and shunted the canoe into the water, then they beckoned to me.

"Go now," said the woman.

"Go where?"

"Yan.—My man tell me come take you go Yan."

"But—the baby—?"

Between Yan and Masset lay ugly waters—I could not—no, I really could not—a tippy little canoe—a woman with her arms full of baby—and a girl child——!

The girl was rigging a ragged flour sack in the canoe for a sail. The pole was already placed, the rag flapped limply round it. The wind and the waves were crisp and sparkling. They were ready, waiting to bulge the sack and toss the canoe.

"How can you manage the canoe and the baby?" I asked the woman and hung back.

Pointing to the bow seat, the woman commanded, "Sit down."

I got in and sat.

The woman waded out holding the canoe and easing it about in the sand until it was afloat. Then she got in and clamped the child between her knees. Her paddle worked without noise among the waves. The wind filled the flour sack as beautifully as if it had been a silk sail.

The canoe took the water as a beaver launches himself—with a silent scoot.

The straight young girl with black hair and eyes and the lank print dress that clung to her childish shape, held the sail rope and humoured the whimsical little canoe. The sack now bulged with wind as tight as once it had bulged with flour. The woman's paddle advised the canoe just how to cut each wave.

We streaked across the water and were at Yan before I remembered to be frightened. The canoe grumbled over the pebbly beach and we got out.

We lit a fire on the beach and ate.

The brave old totems stood solemnly round the bay. Behind them were the old houses of Yan, and behind that again was the forest. All around was a blaze of rosy pink fireweed, rioting from the rich black soil and bursting into loose delicate blossoms, each head pointing straight to the sky.

Nobody lived in Yan. Yan's people had moved to the newer village of Masset, where there was a store, an Indian agent and a church.

Sometimes Indians came over to Yan to cultivate a few patches of garden. When they went away again the stare in the empty

hollows of the totem eyes followed them across the sea, as the mournful eyes of chained dogs follow their retreating masters.

Just one carved face smiled in the village of Yan. It was on a low mortuary pole and was that of a man wearing a very, very high hat of honour. The grin showed his every tooth. On the pole which stood next sat a great wooden eagle. He looked down his nose with a dour expression as a big sister looks when a little sister laughs in church.

The first point at the end of Yan beach was low and covered with coarse rushes. Over it you could see other headlands — point after point... jutting out, on and on... beyond the wide sweep of Yan beach to the edge of the world.

There was lots of work for me to do in Yan. I went down the beach far away from the Indians. At first it was hot, but by and by haze came creeping over the farther points, blotting them out one after the other as if it were suddenly aware that you had been allowed to see too much. The mist came nearer and nearer till it caught Yan too in its woolly whiteness. It stole my totem poles; only the closest ones were left and they were just grey streaks in the mist. I saw myself as a wet rag sticking up in a tub of suds. When the woolly mist began to thread and fall down in rain I went to find the woman.

She had opened one of the houses and was sitting on the floor close to a low fire. The baby was asleep in her lap. Under her shawl she and the child were one big heap in the half-dark of the house. The young girl hugged her knees and looked into the fire. I sat in to warm myself and my clothes steamed. The fire hissed and crackled at us.

I said to the woman, "How old is your baby?"

"Ten month. He not my baby. That," pointing to the girl, "not my chile too."

"Whom do they belong to?"

"Me. One woman give to me. All my chiles die—I got lots, lots dead baby. My fliend solly me 'cause I got no more chile so she give this an' this for mine."

"Gave her children away? Didn't she love them?"

"She love plenty lots. She cly, cly—no eat—no sleep—cly, cly—all time cly."

"Then why did she give her children away?"

"I big fliend for that woman—she solly me—she got lots more baby, so she give this and this for me."

She folded the sleeping child in her shawl and laid him down. Then she lifted up some loose boards lying on the earth floor and there was a pit. She knelt, dipped her hand in and pulled out an axe. Then she brought wood from the beach and chopped as many sticks as we had used for our fire. She laid them near the fire stones, and put the axe in the pit and covered it again. That done, she put the fire out carefully and padlocked the door.

The girl child guiding the little canoe with the flour-sack sail slipped us back through the quiet mist to Masset.

❧ CHA-ATL ❧

WHILE I WAS staying at the missionary's house, waiting to find someone to take me to Cha-atl, the missionary got a farm girl, with no ankles and no sense of humour, to stay there with me. She was to keep me company, and to avoid scandal, because the missionary's wife and family were away. The girl had a good enough heart stowed away in an ox-like body. Her name was Maria.

Jimmie, a Haida Indian, had a good boat, and he agreed to take me to Cha-atl, so he and his wife Louisa, Maria and I all started off in the boat. I took my sheep dog and Louisa took her cat.

We made a short stop at a little island where there were a few totem poles and a great smell because of all the dogfish thrown up on the beach and putrefying in the sun. Then we went on till we got to the long narrow Skidegate Inlet.

The tips of the fresh young pines made circles of pale green from the wide base of each tree to the top. They looked like multitudes of little ladies in crinolines trooping down the bank.

The day was hot and still. Eagles circled in the sky and porpoises followed us up the Inlet till we came to the shallows; they leaped up and down in the water making a great commotion on

both sides of our boat. Their blunt noses came right out of the water and their tails splashed furiously. It was exciting to watch them.

It took Jimmie all his time in the shallows to keep us in the channel. Louisa was at the wheel while he lay face down on the edge of the boat peering into the water and making signals to Louisa with his arms.

In the late afternoon, Jimmie shut off the engine and said, "Listen."

Then we heard a terrific pounding and roaring. It was the surf-beat on the west coast of Queen Charlotte Islands. Every minute it got louder as we came nearer to the mouth of the Inlet. It was as if you were coming into the jaws of something too big and awful even to have a name. It never quite got us, because we turned into Cha-atl just before we came to the corner, so we did not see the awfulness of the roaring ocean. Seamen say this is one of the worst waters in the world and one of the most wicked coasts.

Cha-atl had been abandoned a great many years. The one house standing was quite uninhabitable. Trees had pushed the roof off and burst the sides. Under the hot sun the lush growth smelt rank.

Jimmie lowered the canoe and put Billy, the dog, and me ashore. He left the gas boat anchored far out. When he had put me on the beach, he went back to get Louisa and Maria and the things. While I stood there that awful boom, boom, seemed to drown out every other thing. It made even the forest seem weak and shivery. Perhaps if you could have seen the breakers and had not had the whole weight of the noise left entirely to your ears it would not have seemed so stunning. When the others came ashore the noise seemed more bearable.

There were many fine totem poles in Cha-atl—Haida poles, tragic and fierce. The wood of them was bleached out, but looked green from the mosses which grew in the chinks, and the tufts of grass on the heads of the figures stuck up like coarse hair. The human faces carved on the totem poles were stern and grim, the animal faces fierce and strong; supernatural things were pictured on the poles too. Everything about Cha-atl was so vast and deep you shrivelled up.

When it was too dark to work I came back to the others. They were gathered round a fire on the beach. We did not talk while we ate; you had to shout to be heard above the surf. The smell of the ocean was very strong.

Jimmie had hung one end of my tent to a totem pole that leaned far over the sand. The great carved beaks of the eagle and the raven nearly touched the canvas.

"Jimmie, don't you think that pole might fall on us in the night?"

"No, it has leaned over like that for many, many years."

Louisa's white cat looked like a ghost with the firelight on her eyes. We began to talk about ghosts and supernatural things— tomtoms that beat themselves, animals that spoke like men, bodies of great chiefs, who had lain in their coffins in the houses of their people till they stank and there were small-pox epidemics— stories that Louisa's grandmother had told her.

When we held the face of the clock to the firelight we saw that it was late. Louisa went to the tent and laughed aloud; she called out, "Come and see."

The walls of the tent and our beds and blankets were crawling with great yellow slugs. With sticks we poked them into a pan. They put in their horns and blunted their noses, puckering the

thick lips which ran along their sides and curving their bodies crossly. We tossed them into the bush.

Louisa hung the lantern on to the tent pole and said—

"Jimmie and I will go now."

"Go?"

"Yes, to the gas boat."

" 'Way out there and leave us all alone? Haven't you got a tent?"

Jimmie said he forgot it.

"But . . . Jimmie won't sleep in Cha-atl . . . too many ghosts. . . ."

"What about us?"

"There are some bears around, but I don't think they will bother you. . . . Goodnight."

Their lantern bobbed over the water, then it went out, and there was not anything out there but roar. If only one could have seen it pounding!

We lay down upon the bed of rushes that the Indians had made for us and drew the blanket across us. Maria said, "It's awful. I'm scared to death." Then she rolled over and snored tremendously. Her heavy hands and feet banged about. The thought of those ankles with no taper from calf to foot made me squirm. Our lantern brought in mosquitoes, so I got up and put it out. Then I went from the tent.

Where the sea had been was mud now, a wide grey stretch of it with black rocks and their blacker shadows dotted over it here and there. The moon was rising behind the forest — a bright moon. It threw the shadows of the totems across the sand; an owl cried, and then a sea-bird. To be able to hear these close sounds showed that my ears must be getting used to the breakers. By and by the roar got fainter and fainter and the silence stronger.

The shadows of the totem poles across the beach seemed as real as the poles themselves.

Dawn and the sea came in together. The moon and the shadows were gone. The air was crisp and salty. I caught water where it trickled down a rock and washed myself.

The totem poles stood tranquil in the dawn. The West Coast was almost quiet; the silence had swallowed up the roar.

And morning had come to Cha-atl.

❧ WASH MARY ❧

MARY CAME TO wash for Mother every Monday.

The wash-house was across the yard from the kitchen door—
a long narrow room. The south side of it was of open lattice—
when the steam poured through it looked as if the wash-house
was on fire. There was a stove in the wash-house. A big oval copper
boiler stood on the top of the stove. There was a sink and a pump,
and a long bench on which the wooden tubs sat.

Mary stood on a block of wood while she washed because she
was so little. Her arms went up and down, up and down over the
wash-board and the suds bobbed in the tub. The smell of washing
came out through the lattice with the steam, and the sound of
rubbing and swishing came out too.

The strong colours of Mary's print dress, brown face, and
black hair were paled by the steam that rolled round her from
the tubs. She had splendid braids of hair—the part went clear
from her forehead to her spine. At each side of the part the hair
sprang strong and thick. The plaits began behind each ear. Down
at the ends they were thinner and were tied together with string.
They made a loop across her back that looked like a splendid
strong handle to lift little Mary up by. Her big plaid shawl hung

on a nail while she washed. Mary's face was dark and wrinkled and kind.

MOTHER SAID TO me, "Go across the yard and say to Mary, 'Chahko muckamuck, Mary.'"

"What does it mean?"

"Come to dinner."

"Mother, is Mary an Indian?"

"Yes child; run along, Mary will be hungry."

"Chahko muckamuck—chahko muckamuck—" I said over and over as I ran across the yard.

When I said to Mary, "Chahko muckamuck," the little woman looked up and laughed at me just as one little girl laughs at another little girl.

I used to hang round at noon on Mondays so that I could go and say, "Chahko muckamuck, Mary." I liked to see her stroke the suds from her arms back into the tub and dry her arms on her wide skirt as she crossed to the kitchen. Then too I used to watch her lug out the big basket and tiptoe on her bare feet to hang the wash on the line, her mouth full of clothes-pins—the old straight kind that had no spring, but round wooden knobs on the top that made them look like a row of little dolls dancing over the empty flapping clothes.

As long as I could remember Mary had always come on Mondays and then suddenly she did not come any more.

I asked, "Where is Wash Mary?"

Mother said, "You may come with me to see her."

We took things in a basket and went to a funny little house in Fairfield Road where Mary lived. She did not stay on the Reserve where the Songhees Indians lived. Perhaps she belonged to a

different tribe—I do not know—but she wanted to live as white people did. She was a Catholic.

Mary's house was poor but very clean. She was in bed; she was very, very thin and coughed all the time. The brown was all bleached out of her skin. Her fingers were like pale yellow claws now, not a bit like the brown hands that had hung the clothes on our line. Just her black hair was the same and her kind, tired eyes.

She was very glad to see Mother and me.

Mother said, "Poor Mary," and stroked her hair.

A tall man in a long black dress came into Mary's house. He wore a string of beads with a cross round his waist. He came to the bed and spoke to Mary and Mother and I came away.

After we were outside again, Mother said quietly—"Poor Mary!"

✂ JUICE ✂

IT WAS UNBELIEVABLY hot. We three women came out of the store each eating a juicy pear. There was ten cents' express on every pound of freight that came up the Cariboo road. Fruit weighs heavy. Everything came in by mule-train.

The first bite into those Bartletts was intoxicating. The juice met your teeth with a gush.

I was considering the most advantageous spot to set my bite next when I saw Doctor Cabbage's eyes over the top of my pear, feasting on the fruit with unquenched longing.

I was on the store step, so I could look right into his eyes. They were dry and filmed. The skin of his hands and face was shrivelled, his clothes nothing but a bunch of tatters hanging on a dry stick. I believe the wind could have tossed him like a dead leaf, and that nothing juicy had ever happened in Doctor Cabbage's life.

"Is it a good apple?"

After he had asked, his dry tongue made a slow trip across his lips and went back into his mouth hotter and dryer for thinking of the fruit.

"Would you like it?"

A gleam burst through his filmed eyes. He drew the hot air into his throat with a gasp, held his hand out for the pear and then took a deep greedy bite beside mine.

The juice trickled down his chin—his tongue jumped out and caught it; he sipped the oozing juice from the holes our bites had made. He licked the drops running down the rind, then with his eyes still on the pear, he held it out for me to take back.

"No, it's all yours."

"Me eat him every bit?"

"Yes."

His eyes squinted at the fruit as if he could not quite believe his ears and that all the pear in his hands belonged to him. Then he took bite after bite, rolling each bite slowly round his mouth, catching every drop of juice with loud suckings. He ate the core. He ate the tail, and licked his fingers over and over like a cat.

"Hyas Klosshe" (very good), he said, and trotted up the hill as though his joints had been oiled.

SOME DAYS LATER I had occasion to ride through the Indian village. All the cow ponies were busy—the only mount available was an old, old mare who resented each step she took, and if you stopped one instant she went fast asleep.

Indian boys were playing football in the street of their village. I drew up to ask direction. The ball bounced exactly under my horse's stomach. The animal had already gone to sleep and did not notice. Out of a cabin shot a whirl of a little man, riddled with anger. It was Doctor Cabbage.

He confiscated the ball and scolded the boys so furiously that the whole team melted away—you'd think there was not a boy left in the world.

Laying his hand on my sleeping steed, Doctor Cabbage smiled up at me.

"You brave good rider," he said, "Skookum tumtum!" (good heart).

I thanked Doctor Cabbage for the compliment and for his gallant rescue.

I woke my horse with great difficulty, and decided that honour for conspicuous bravery was sometimes very easily won.

✂ FRIENDS ✂

"WE HAVE A good house now. We would like you to stay with us when you come. My third stepfather gave me the house when he was dead. He was a good man."

I wrote back, "I would like to stay with you in your house."

Louisa met me down on the mud flats. She had to walk out half a mile because the tide was low. She wore gum boots and carried another pair in her hand for me. Her two small barefoot sons took my bags on their backs. Louisa's greetings were gracious and suitable to the dignity of her third stepfather's house.

It was a nice house, and had a garden and verandah. There was a large kitchen, a living-room and double parlours. The back parlour was given to me. It had a handsome brass bed with spread and pillow-slips heavily embroidered, and an eiderdown. There was also a fine dresser in the room; on it stood a candle in a beer bottle and a tin pie-plate to hold hairpins. There was lots of light and air in the room because the blind would not draw down and the window would not shut up.

A big chest in the centre of the room held the best clothes of all the family. Everyone was due to dress there for church on Sunday morning.

Between my parlour and the front parlour was an archway hung with skimpy purple curtains of plush. If any visitors came for music in the evenings and stayed too long, Louisa said,

"You must go now, my friend wants to go to bed."

The outer parlour ran to music. It had a player-piano—an immense instrument with a volume that rocked the house— an organ, a flute and some harmonicas. When the cabinet for the player rolls, the bench, a big sofa, a stand-lamp with shade, and some rocking chairs got into the room, there was scarcely any space for people.

In the living-room stood a glass case and in it were Louisa's and Jimmie's wedding presents and all their anniversary presents. They had been married a long time, so the case was quite full.

The kitchen was comfortable, with a fine cook-stove, a sink, and a round table to eat off. Louisa had been cook in a cannery and cooked well. Visitors often came in to watch us eat. They just slipped in and sat in chairs against the wall and we went on eating. Mrs. Green, Louisa's mother, dropped in very often. Louisa's house was the best in the village.

At night Louisa's boys, Jim and Joe, opened a funny little door in the living-room wall and disappeared. Their footsteps sounded up and more up, a creak on each step, then there was silence. By and by Jimmie and Louisa disappeared through the little door too. Only they made louder creaks as they stepped. The house was then quite quiet—just the waves sighing on the shore.

LOUISA'S MOTHER, MRS. GREEN, was a remarkable woman. She clung vigorously to the old Indian ways, which sometimes embarrassed Louisa. In the middle of talking, the old lady would spit onto the wood-pile behind the stove. When Louisa saw she

was going to, she ran with a newspaper, but she seldom got there in time. She was a little ashamed, too, of her mother's smoking a pipe; but Louisa was most respectful to her mother—she never scolded her.

One day I was passing the cabin in the village where Mrs. Green lived. I saw the old lady standing barefoot in a trunk which was filled with thick brown kelp leaves dried hard. They were covered with tiny grey eggs. Louisa told me it was fish roe and was much relished by the Japanese. Mrs. Green knew where the fish put their eggs in the beds of kelp, and she went out in her canoe and got them. After she had dried them she sent them to the store in Prince Rupert and the store shipped them to Japan, giving Mrs. Green value in goods.

When Mrs. Green had tramped the kelp flat, Louisa and I sat on the trunk and she roped it and did up the clasps. Then we put the trunk on the boys' little wagon and between us trundled it to the wharf. They came home then to write a letter to the store man at Prince Rupert. Louisa got the pen and ink, and her black head and her mother's grey one bent over the kitchen table. They had the store catalogue: it was worn soft and black. Mrs. Green had been deciding all the year what to get with the money from the fish roe. Louisa's tongue kept lolling out of the corner of her mouth as she worried over the words; she found them harder to write than to say in English. It seemed as if the lolling tongue made it easier to put them on the paper.

"Can I help you?" I asked.

Louisa shoved the paper across the table to me with a glad sigh, crushing up her scrawled sheet. They referred over and over to the catalogue, telling me what to write. "One plaid shawl with fringe, a piece of pink print, a yellow silk handkerchief, groceries"

were all written down, but the old woman kept turning back the catalogue and Louisa kept turning it forward again and saying firmly, "That is all you need, Mother!" Still the old woman's fingers kept stealthily slipping back the pages with longing.

I ended the letter and left room for something else on the list.

"Was there anything more that you wanted, Mrs. Green?"

"Yes, me like *that*!" she said with a defiant glance at Louisa.

It was a patent tobacco pipe with a little tin lid. Louisa looked shamed.

"What a fine pipe, Mrs. Green, you ought to have that," I said.

"Me like little smoke," said Mrs. Green, looking slyly at Louisa.

"So do I, Mrs. Green."

"The Missionary says ladies do not smoke," said Louisa doubtfully.

That night, old Mother Green sat by the stove puffing happily on her old clay pipe. She leaned forward and poked my knee. "That lid good," she said. "When me small, small girl me mamma tell me go fetch pipe often; I put in my mouth to keep the fire; that way me begin like smoke." She had a longish face scribbled all over with wrinkles. When she talked English the big wrinkles round her eyes and mouth were seams deep and tight and little wrinkles, like stitches, crossed them.

THE CANDLE IN my room gave just enough light to show off the darkness. Morning made clear the picture that was opposite my bed. It was of three very young infants. How they could stick up so straight with no support at that age was surprising. They had embroidered robes three times as long as themselves, and the most amazing expressions on their faces. Their six eyes were shut

as tight as licked envelopes—the infants, clearly, had tremendous wills, and had determined never to open their eyes. Their little faces were like those of very old people; their fierce wrinkles seemed to catch and pinch my stare, so that I could not get it away. I stared and stared. Louisa found me staring.

I said, "Whose babies are those?"

"Mother's tripples," she replied grandly.

"You mean they were Mrs. Green's babies?"

"Yes, the only tripples ever born on Queen Charlotte Islands."

"Did they die?"

"One died and the other two never lived. We kept the dead ones till the live one died, then we pictured them all together."

Whenever I saw that remarkable old woman, with her hoe and spade, starting off in her canoe to cultivate the potatoes she grew wherever she could find a pocket of earth on the little islands round about, I thought of the "tripples". If they had lived and had inherited her strength and determination, they could have rocked the Queen Charlotte Islands.

ON SUNDAY, LOUISA opened the chest in my room and dressed her family. Then we all went to church.

The Missionary and his sister shook hands with us and asked us to tea the next day. Louisa could not go, but I went.

The Missionary said, "It is good for the Indians to have a white person stay in their homes; we are at a very difficult stage with them—this passing from old ways into new. I tell you savages were easier to handle than these half-civilized people . . . in fact it is impossible. . . . I have sent my wife and children south. . . ."

"Is the school here not good?"

"I can't have my children mix with the Indians."

A long pause, then, "I want to ask you to try to use your influence with Louisa and her husband to send their boys to the Industrial boarding-school for Indians. Will you do so?" asked the Parson.

"No."

The Missionary's eyes and his sister's glared at me through their spectacles like fish eyes.

"Why will you not?"

"In Louisa's house now there is an adopted child, a lazy, detestable boy, the product of an Indian Industrial School, ashamed of his Indian heritage. All Louisa's large family of children are dead, all but these two boys, and they are not robust. Louisa knows how to look after them—there is a school in the village. She can send them there and own and mother them during their short lives. Why should she give up her boys?"

"But the advantages?"

"And the disadvantages!"

LOUISA AND I sat by the kitchen stove. Joe, her younger son, had thrown himself across her lap to lull a toothache; his cheeks were thin and too pink. Louisa said, "The Missionary wants us to send our boys away to school."

"Are you going to?"

"—Maybe Jimmy by and by—he is strong and very bright, not this one—."

"I never saw brighter eyes than your Joe has."

Louisa clutched the boy tight. "Don't tell me that. They say shiny eyes and pink cheeks mean—... If he was your boy, Em'ly, would you send him away to school?"

"NO."

MARTHA'S JOEY

ONE DAY OUR father and his three little girls were going over James Bay Bridge in Victoria. We met a jolly-faced old Indian woman with a little fair-haired white boy about as old as I was.

Father said, "Hello Joey!" and to the woman he said: "How are you getting on, Martha?"

Father had given each of us a big flat chocolate in silver paper done up like a dollar piece. We were saving them to eat when we got home.

Father said, "Who will give her chocolate to Joey?"

We were all willing. Father took mine because I was the smallest and the greediest of his little girls.

The boy took it from my hand shyly, but Martha beamed so wide all over me that I felt very generous.

After we had passed on I said, "Father, who is Joey?"

"Joey," said my father, "was left when he was a tiny baby at Indian Martha's house. One very dark stormy night a man and woman knocked at her door. They asked if she would take the child in out of the wet, while they went on an errand. They would soon be back, they said, but they never came again, though Martha went on expecting them and caring for the child. She washed the fine

clothes he had been dressed in and took them to the priest; but nobody could find out anything about the couple who had forsaken the baby.

"Martha had no children and she got to love the boy very much. She dressed him in Indian clothes and took him for her own. She called him Joey."

I OFTEN THOUGHT about what Father had told us about Joey.

One day Mother said I could go with her, and we went to a little hut in a green field where somebody's cows grazed. That was where Martha lived.

We knocked at the door but there was no answer. As we stood there we could hear some one inside the house crying and crying. Mother opened the door and we went in.

Martha was sitting on the floor. Her hair was sticking out wildly, and her face was all swollen with crying. Things were thrown about the floor as if she did not care about anything any more. She could only sit swaying back and forth crying out, "Joey—my Joey—my Joey—."

Mother put some nice things on the floor beside her, but she did not look at them. She just went on crying and moaning.

Mother bent over Martha and stroked her shoulder; but it was no good saying anything, she was sobbing too hard to hear. I don't think she even knew we were there. The cat came and cried and begged for food. The house was cold.

Mother was crying a little when we came away.

"Is Joey dead, Mother?"

"No, the priests have taken him from Martha and sent him away to school."

"Why couldn't he stay with Martha and go to school like other Indian boys?"

"Joey is not an Indian; he is a white boy. Martha is not his mother."

"But Joey's mother did not want him; she gave him away to Martha and that made him her boy. He's hers. It's beastly of the priest to steal him from Martha."

MARTHA CRIED TILL she had no more tears and then she died.

✂ SALT WATER ✂

AT FIVE O'CLOCK that July morning the sea, sky, and beach of Skidegate were rosily smoothed into one. There was neither horizon, cloud, nor sound; of that pink, spread silence even I had become part, belonging as much to sky as to earth, as much to sleeping as waking as I went stumbling over the Skidegate sands.

At the edge of the shrunken sea some Indians were waiting for me, a man and his young nephew and niece. They stood beside the little go-between canoe which was to carry us to a phantom gas boat floating far out in the Bay.

We were going to three old forsaken villages of the British Columbia Indians, going that I might sketch. We were to be away five days.

"The morning is good," I said to the Indian.

"Uh huh," he nodded.

The boy and the girl shrank back shyly, grinning, whispering guttural comments upon my Ginger Pop, the little griffon dog who trotted by my side.

In obedience to a grunt and a pointing finger, I took my place in the canoe and was rowed out to the gas boat. She tipped peevishly as I boarded, circling a great round "O" upon the glassy

water; I watched the "O" flatten back into smoothness. The man went to fetch the girl and boy, the food and blankets.

I had once before visited these three villages, Skedans, Tanoo and Cumshewa. The bitter-sweet of their overwhelming loneliness created a longing to return to them. The Indian had never thwarted the growth-force springing up so terrifically in them. He had but homed himself there awhile, making use of what he needed, leaving the rest as it always was. Civilization crept nearer and the Indian went to meet it, abandoning his old haunts. Then the rush of wild growth swooped and gobbled up all that was foreign to it. Rapidly it was obliterating every trace of man. Now only a few hand-hewn cedar planks and roof beams remained, moss-grown and sagging—a few totem poles, greyed and split.

We had been scarcely an hour on the sea when the rosiness turned to lead, grey mist wrapped us about and the sea puckered into sullen, green bulges.

The Indians went into the boat's cabin. I preferred the open. Sitting upon a box, braced against the cabin wall, I felt very ill indeed. There was no deck rail, the waves grew bigger and bigger licking hungrily towards me. I put the dog in his travelling box and sent him below.

Soon we began dipping into green valleys, and tearing up erupting hills. I could scarcely retain my grip on the box. It seemed as if my veins were filled with sea water rather than blood, and that my head was full of emptiness.

After seven hours of this misery our engine shut off outside Skedans Bay. The Indian tossed the anchor overboard. My heart seemed to go with it in its gurgling plop to find bottom, for mist had turned to rain and Skedans skulked dim and uninviting.

"Can the boat not go nearer?"

The Indian shook his head. "No can, water floor welly wicked, make boat bloke." I knew that there were kelp beds and reefs which could rip the bottoms from boats down in Skedans Bay.

"Eat now?" asked the man.

"No, I want to land."

The canoe sighed across our deck. The waves met her with an angry spank. The Indian juggled her through the kelp. Kelpie heads bobbed around us like drowning Aunt Sallies, flat brown streamers growing from their crowns and floating out on the waves like long tresses. The sea battered our canoe roughly. Again and again we experienced nightmare drownings, which worked up and up to a point but never reached there. When we finally beached, the land was scarcely less wet than the sea. The rain water lacked the sting of salt but it soaked deeper.

The Indian lit a great fire for me on the beach; then he went back to his gas boat, and a wall of mist and rain cut me off from all human beings.

Skedans on a stormy day looked menacing. To the right of the Bay immediately behind the reef, rose a pair of uncouth cone-like hills, their heads bonneted in lowering clouds. The clumsy hills were heavily treed save where deep bare scars ran down their sides, as if some monster cruelty had ripped them from crown to base. Behind these two hills the sea bit into the shoreline so deeply as to leave only a narrow neck of land, and the bedlam of waves pounding on the shores back and front of the village site pinched the silence out of forsaken old Skedans.

Wind raced across the breast-high growth around the meagre ruins more poignantly desolate for having once known man.

A row of crazily tipped totem poles straggled along the low bank skirting Skedans Bay. The poles were deep planted to defy

storms. In their bleached and hollow upper ends stood coffin-boxes, boarded endwise into the pole by heavy cedar planks boldly carved with the crest of the little huddle of bones inside the box, bones which had once been a chief of Eagle, Bear or Whale Clan.

Out in the anchored gas boat the Indian girl became seasick, so they brought her ashore. Leaving her by the fire I wandered to the far end of the Bay. Ginger Pop was still on the gas boat and I missed him at my heels for the place was very desolate, awash with rain, and the sea pounding and snatching all it could reach, hurling great waves only to snatch them back to increase the volume of its next blow.

Suddenly above the din rose a human cry. The girl was beckoning to me wildly. "Uncle's boat," she cried. "It is driving for the reef!"

I saw the gas boat scudding towards her doom, saw the Indian in the small canoe battling to make shore with our bedding and food.

"Listen!" screamed the girl. "It is my brother."

Terrified shrieks from the gas boat pierced the tumult, "Uncle, Uncle!"

The man hurled the food and blankets ashore without beaching the canoe, then he stepped into the waves, holding the frantic thing like a dog straining on a leash. He beckoned me as near as the waves would let me go.

"Water heap wicked—maybe no come back—take care my girl," he said, and was gone.

Rushing out to the point above the reef, we watched the conflict between canoe and sea. When the man reached the gas boat, the screams of the boy stopped. With great risk they loaded the canoe till she began to take water. The boy bailed furiously. The long dogged pull of the man's oars challenged death inch by

inch, wave by wave. There were spells like eternity, when the fury out there seemed empty, when the girl hid her face on my shoulder and screeched. I stared and stared, watching to tell the Indians in the home village what the sea had done to their man and boy. How it had sucked them again and again into awful hollows, walled them about with waves, churned so madly that the boat did not budge in spite of those desperate pulling oars.

Then some sea demon tossed her upon a crest and another plunged her back again. The hugging sea wanted her, but inch by inch she won. Then a great breaker dashed her on the beach with the smashing hurl of a spoiled child returning some coveted toy.

The boy jumped out and made fast. The man struggled a few paces through the foam and fell face down. We dragged him in. His face was purple. "He is dying!"—No, life came back with tearing sobs.

Among our sodden stuff was a can of milk, another of beans; we heated them, they put new life into us. Night was coming. We made what preparation we could, spreading a tent-fly over a great log and drying out our blankets. There was no lack of driftwood for the fire.

The Indian's heart was sore for his boat; it looked as if nothing could save her. She was drifting more slowly now, her propeller fouled in kelp.

Mine was sore for my Ginger Pop in his box on the doomed boat. We each took our trouble to an opposite end of the bay... brooding.

Suddenly the mournful little group on the farther point galvanized into life. I heard a chorus of yells, saw the man strip off his oilskin pants, tie them to a pole and beat the air. I hurried across but found the Indians limp and despairing again.

"Boat see we was Indian, no stop," said the man bitterly.

Fish boats were hurrying to shelter, few came our way, sanctuary was not to be found in Skedans Bay. I could not help hoping none would see our distress signal. The thought of going out on that awful sea appalled me.

A Norwegian seine boat did see us however. She stood by and sent two small boats ashore. One went to the rescue of the drifting gas boat and the other beached for us.

"Please, please leave us here on the land," I begged. The Indians began rushing our things into the boat and the big Norwegian sailors with long beards like brigands said, "Hurry! Hurry!" I stood where land and sea wrangled ferociously over the overlap. The tea kettle was in my hand. "Wait," I roared above the din of the waves, seeing I was about to be seized like a bale of goods and hurled into the boat. "Wait!"—plunging a hand into my pocket I took out a box of "Mothersill's Seasick Remedy", unwrapped a pill, put it on my tongue and took a gulp from the kettle's spout; then I let them put me into the maniac boat. She was wide and flat-bottomed. It was like riding through bedlam on a shovel. "Mothersill" was useless; her failure climaxed as we reached the seiner, which at that particular moment was standing on her nose. When she sat down again they tied the rescued gas boat to her tail and dragged us aboard the seiner. When they set me on the heaving deck, I flopped on top of the fish hatch and lay there sprawling like a star fish.

Rooting among my things the Indian girl got a yellow parasol and a large tin cup; but the parasol flew overboard and the cup was too late—it went clanking down the deck. Being now beyond decency I made no effort to retrieve it. The waves did better than the cup anyway, gurgling and sloshing around the hatch which

was a foot higher than the deck. Spray washed over me. The taste of the sea was on my lips.

The Captain ordered "all below"; everyone rushed to obey save me. I lay among the turmoil with everything rattling and smashing around and in my head no more sense than a jelly fish.

Then the Captain strode across the deck, picked me up like a baby and dumped me into the berth in his own cabin. I am sure it must have been right on top of the boiler for I never felt so hot in my life. One by one my senses clicked off as if the cigarette ladies jazzing over every inch of the cabin walls had pressed buttons.

When I awoke it hardly seemed possible that this was the same boat or the same sea or that this was the same me lying flat and still above an engine that purred soft and contented as an old cat. Then I saw that the Indian girl was beside me.

"Where are we?"

"I dunno."

"Where are they taking us?"

"I dunno."

"What time is it?"

"I dunno."

"Is Ginger Pop safe?"

"I dunno."

I turned my attention to the Captain's cabin, lit vaguely from the deck lantern. The cigarette ladies now sat steady and demure. From the window I could see dark shore close to us. Suddenly there was no more light in the room because the Captain stood in the doorway, and said, as casually as if he picked up castaways off beaches most nights,

"Wants a few minutes to midnight—then I shall put you off at the scows."

"The scows?"

"Yep, scows tied up in Cumshewa Inlet for the fish boats to dump their catches in."

"What shall I do there?"

"When the scows are full, 'packers' come and tow them to the canneries."

"And I must sit among the fish and wait for a packer?"

"That's the idea."

"How long before one will come?"

"Ask the fish."

"I suppose the Indians will be there too?"

"No, we tow them on farther, their engine's broke."

Solitary, uncounted hours in one of those hideous square-snouted pits of fish smell! Already I could feel the cold brutes slithering around me for aeons and aeons of time before the tow ropes went taut, and we set out for the cannery. There, men with spiked poles would swarm into the scow, hook each fish under the gills. The creatures would hurtle through the air like silver streaks, landing into the cannery chutes with slithery thumps, and pass on to the ripping knives.... The Captain's voice roused me from loathsome thoughts.

"Here we are!"

He looked at me—scratched his head—frowned. "We're here," he repeated, "and now what the dickens—? There is a small cabin on the house scow—that's the one anchored here permanently—but the two men who live on it will have been completely out these many hours. Doubt if sirens, blows, nor nothin' could rouse 'em. Well, see what I can do...."

He disappeared as the engine bell rang. The Indian girl, without goodbye, went to join her uncle.

Captain returned jubilant.

"There is a Jap fish boat tied to the scows. Her Captain will go below with his men and let you have his berth till four A.M.; you'll have to clear out then—that's lookin' far into the future tho'. Come on."

I followed his bobbing lantern along a succession of narrow planks mounted on trestles, giddy, vague as walking a tight rope across night. We passed three cavernous squares of black. Fish smell darted at us from their depths. When the planks ended the Captain said, "Jump!" I obeyed wildly, landing on a floored pit filled with the most terrifying growls.

"Snores," said the captain. "...House scow."

We tumbled over strange objects, the door knob of the cabin looked like a pupil-less eye as the lantern light caught its dead stare.

We scrambled up the far side of the scow pit and so on to the Jap boat; three steps higher and we were in the wheel house. There was a short narrow bench behind the wheel—this was to be my bed. On it was my roll of damp blankets, my sketch sack, and Ginger Pop's box with a mad-for-joy Ginger inside it, who transformed me immediately back from a bale of goods to his own special divinity.

The new day beat itself into my consciousness under the knuckles of the Japanese captain. I thanked my host for the uncomfortable night which, but for his kindness, would have been far worse, and biddably leapt from the boat to the scow. It seemed that now I had no more voice in the disposal of my own person than a salmon. I was goods—I made no arrangements, possessed neither ticket, pass, nor postage stamp—a pick-up that somebody asked someone else to dump somewhere.

At the sound of my landing in the scow bottom, the door of the cabin opened, and yellow lamplight trickled over a miscellany of objects on the deck. Two men peered from the doorway; someone had warned them I was coming. Their beds were made, the cabin was tidied, and there were hot biscuits and coffee on the table.

"Good morning, I am afraid I am a nuisance.... I'm sorry."

"Not at all, not at all, quite a—quite er—" he gave up before he came to what I was and said, "Breakfast's ready... crockery scant... but plenty grub, plenty grub;... cute nipper," pointing to Ginger Pop. "Name?"

"Ginger Pop."

"Ha! Ha!" He had a big round laugh. "Some name, some pup, eh?"

The little room was of rough lumber. It contained two of each bare necessity—crockery, chairs, beds, two men, a stove, a table.

"Us'll have first go," said the wider, the more conversational of the two. He waved me into one of the chairs and took the other.

"This here," thumbing back at the dour man by the stove, "is Jones; he's cook, I'm Smith."

I told them who I was but they already knew all about us. News travels quickly over the sea top. Once submerged and it is locked in secrecy. The hot food tasted splendid. At last we yielded the crockery to Jones.

"Now," said Smith, "you've et well; how'd you like a sleep?"

"I should like to sleep very much indeed," I replied, and without more ado, hat, gum boots and all, climbed up onto Smith's bed. Ginger Pop threw himself across my chest with his nose tucked under my chin. I pulled my hat far over my face. The dog instantly began to snore. Smith thought it was I. "Pore soul's dead beat," he whispered to Jones, and was answered by a "serves-'er-right" grunt.

It was nearly noon when I awoke. I could not place myself underneath the hat. The cabin was bedlam. Jones stretched upon his bed was snoring, Smith on the floor with my sketch sack for a pillow "duetted", Ginger Pop under my chin was doing it too. The walls took the snores and compounded them into a hodge-podge chorus and bounced it from wall to wall.

Slipping off the bed and stepping gingerly over Smith I went out of the cabin into the fullness of a July noon, spread munificently over the Cumshewa Inlet. The near shores were packed with trees, trees soaked in sunshine. For all their crowding, there was room between every tree, every leaf, for limitless mystery. On many of their tops sat a bald-headed eagle, fish glutted, his white cap startling against the deep green of the fir trees. No cloud, no sound, save only the deep thunderous snores coming from the cabin. The sleeping men were far, far away, no more here than the trouble of last night's storm was upon the face of the Inlet.

The door of the cabin creaked. Smith's blinky eye peeped out to see if he had dreamed us. When he saw Ginger and me he beamed, hoped we were rested, hoped we were hungry, hoped Jones' dinner would be ready soon; then the door banged, shutting himself and his hopes into the cabin. He was out again soon, carrying a small tin basin, a grey towel, and a lump of soap. Placing the things on a barrel-end, he was just about to dip when the long neck of Jones twisted around Smith's body and plunged first with loud sputters. Still dripping he rushed back among the smells of his meat and dumplings. Smith refilled the basin and washed himself with amazing thoroughness considering his equipment, engaging me in conversation all the while. After he had hurled the last remaining

sud into the sea he filled the basin yet again, solemnly handed me the soap and, polishing his face as if it had been a brass knob, shut Jones and himself up and left me to it.

We dined in the order we had breakfasted.

"Mr. Smith," I said, "how am I going to get out of here?"

"That is," said Smith with an airy wave of his knife, "in the hands of the fish."

"They haven't any," I replied a little sulkily. The restriction of four walls and two teacups was beginning to tell and nobody seemed to be doing anything about releasing me.

"Pardon, Miss, I were speakin' figurative. Meanin' that if them fish critters is reasonable there'll be boats; after boats there'll be packers."

"Easy yourself now," he coaxed, " 'Ave another dumpling?"

Ginger and I scrambled over the various scows getting what peeps of the Inlet we could. It was very beautiful.

By and by we saw the scrawny form of Jones hugging the cabin close while he eased his way with clinging feet past the scow house to the far end. Here he leaned from the overhang and like a magician, produced a little boat from nowhere.

He saw us watching and had a happy thought. He could relieve the congestion in the scow house. He actually grinned—"Going to the spring. You and the dog care for a spell ashore?" He helped Ginger across the ledge and the awkward drop into the boat, but left me to do the best I could. I was thicker than Jones and the rim of the boat beyond the cabin was very meagre.

The narrow beach was covered with sea-drift. Silence and heat lay heavy upon it. Few breezes found their way up the Inlet. The dense shore growth was impossible to break into. Jones

filled his pails at the spring and returned to the scow, leaving us stranded on the shore. When the shadows were long he returned for us. As we were eating supper, night fell.

We sat around the coal-oil lamp which stood upon the table, telling stories. At the back of each mind was a wonder as to whose lot would be cast on the floor if no packer came before night. Little fish boats began to come. We went out to watch them toss their catch hastily into the scows and rush back like retrieving pups to fetch more.

There was a great bright moon now. The fish looked alive, shooting through the air. In the scows they slithered over one another, skidding, switchbacking across the silver mound till each found a resting-place only to be bounced out by some weightier fellow.

The busy little boats broke the calm and brought a tang of freshness from the outside to remind the Inlet that she too was part of the great salt sea.

So absorbed was I in the fish that I forgot the packer till I heard the enthusiastic ring in Jones' voice as he cried, "Packer!" He ran to his cupboard and found a bone for Ginger while Smith parleyed with the packer's Japanese captain. Yes, he was going my way. He would take me.

Smith led me along the narrow plank walk and gave me into the Captain's care. Besides myself there was another passenger, a bad-tempered Englishman with a cold in his head. As there was nowhere else, we were obliged to sit side by side on the red plush cushion behind the Captain and his wheel. All were silent as we slipped through the flat shiny water bordered on either side by mountainous fir-treed shores. The tree tops looked like interminable picket fences silhouetted against the sky, with water shadows as sharp and precise as themselves.

My fellow passenger coughed, hawked, sneezed and sniffed. Often he leaned forward and whispered into the Captain's ear. Then the Captain would turn and say to me, "You wish to sleep now? My man will show you." I knew it was "Sniffer" wanting the entire couch and I clung to the red plush like a limpet. By and by however, we came to open water and began to toss, and then I was glad to be led away by the most curious little creature. Doubtless he had a middle because there was a shrivelled little voice pickled away somewhere in his vitals, but his sou'wester came so low and his sea-boots so high, the rest of him seemed negligible.

This kind little person navigated me successfully over the deck gear, holding a lantern and giving little inarticulate clucks continuously, but my heart struck bottom when he slid back a small hatch and sank into the pit by jerks till he was all gone but the crown of his sou'wester.

"Come you please, lady," piped the queer little voice. There was barely room for our four feet on the floor between the two pair of short narrow bunks which tapered to a point in the stern of the boat. To get into a berth you must first horizontal yourself, then tip and roll. "Sou'wester-Boots" steadied me and held aside fishermen's gear while I tipped, rolled, and scraped my nose on the underneath of the top bunk.

"I do wish you good sleep, lady."

My escort and the light were gone. The blackness was intense and heavy with the smell of fish and tar.

I was under the sea, could feel it rushing by on the other side of the thin boards, kissing, kissing the boat as it passed. Surely at any moment it would gush into my ears. At the back of the narrow berth some live-seeming thing grizzled up my spine, the engine bell rang and it scuttled back again; then the rudder groaned, and

I knew what the thing was. Soon the mechanics of the boat seemed to be part of myself. I waited for the sequence—bell, grizzle, groan—bell, grizzle, groan; they had become part of me.

Several times during the night the hatch slid back, a lantern swung into my den and shadow hands too enormous for this tiny place reached for some article.

"I am afraid I am holding up all the sleeping quarters," I said.

"Please, lady, nobody do sleep when at night we go."

I floated in and out of consciousness, and dream fish swam into my one ear and out of the other.

At three A.M. the rudder cable stopped playing scales on my vertebrae. The boat still breathed but she did not go. Sou'wester opened my lid and called, "Please, lady, the Cannery."

I rolled, righted, climbed, followed. He carried my sketch sack and Ginger's box. We took a few steps and then the pulse of the engine was no longer under our feet. We stood on some grounded thing that had such a tilt it pushed against our walking. We came to the base of an abnormally long perpendicular fish ladder, stretching up, up into shadow so overwhelmingly deep it seemed as if a pit had been inverted over our heads. It was the wharf and Cannery.

A bulky object mounted the ladder, and was swallowed into the gloom. After a second a spot of dim light dangled high above. Breaths cold and deathly came from the inky velvet under the wharf. I could hear mud sucking sluggishly around the base of piles, the click of mussels and barnacles, the hiss and squirt of clams. From far above came a testy voice... "Come on, there." There were four sneezes, the lantern dipping at each sneeze.

"Quick, go!" said Sou'wester. "Man do be mad."

I could not... could not mount into that giddy blackness; that weazened little creature, all hat and boots, was such a tower of strength to abandon for a vague black ascent into... nothingness.

"Couldn't I... couldn't I crawl under the wharf round to the beach?" I begged.

"It is not possible, go!"

"The dog?"

"He... you see!" Even as he spoke, Ginger's box swung over my head.

"What's the matter down there?... Hurry!"

I grasped the cold slimy rung. My feet slithered and scrunched on stranded things. Next rung... the next and next... endless horrible rungs, hissings and smells belching from under the wharf. These things at least were half tangible. Empty nothingness, behind, around; hanging in the void, clinging to slipperiness, was horrible—horrible beyond words!...

Only one more rung, then the great timber that skirted the wharf would have to be climbed over and with no rung above to cling to....

The impact of my body, flung down upon the wharf, jerked my mind back from nowhere.

"Fool! Why did you let go?" "Sneezer" retrieved the lantern he had flung down, to grip me as I reeled.... Six sneezes... dying footsteps... dark.

I groped for the dog's box.

Nothing amazed Ginger Pop. Not even that his mistress should be sitting T-squared against wharf and shed... time, three A.M.... place, a far north Cannery of British Columbia.

❧ CENTURY TIME ❧

YOU WOULD NEVER guess it was a cemetery. Death had not spoiled it at all.

It was full of trees and bushes except in one corner where the graves were. Even they were fast being covered with greenery.

Bushes almost hid the raw, split-log fence and the gate of cedar strips with a cross above it, which told you that the enclosed space belonged to the dead. The land about the cemetery might change owners, but the ownership of the cemetery would not change. It belonged to the dead for all time.

Persistent growth pushed up through the earth of it—on and on eternally—growth that was the richer for men's bodies helping to build it.

The Indian settlement was small. Not many new graves were required each year. The Indians only cleared a small bit of ground at a time. When that was full they cleared more. Just as soon as the grave boxes were covered with earth, vines and brambles began to creep over the mounds. Nobody cut them away. It was no time at all before life spread a green blanket over the Indian dead.

It was a quiet place this Indian cemetery, lying a little aloof from the village. A big stump field, swampy and green, separated them. Birds called across the field and flew into the quiet tangle of the cemetery bushes and nested there among foliage so newly created that it did not know anything about grime. There was no road into the cemetery to be worn dusty by feet, or stirred into gritty clouds by hearse wheels. The village had no hearse. The dead were carried by friendly hands across the stump field.

The wooded part of the cemetery dropped steeply to a lake. You could not see the water of the lake because of the trees, but you could feel the space between the cemetery and the purple-topped mountain beyond.

In the late afternoon a great shadow-mountain stepped across the lake and brooded over the cemetery. It had done this at the end of every sunny day for centuries, long, long before that piece of land was a cemetery. Dark came and held the shadow-mountain there all night, but when morning broke, it was back again inside its mountain, which pushed its grand purple dome up into the sky and dared the pines swarming around its base to creep higher than half-way up its bare rocky sides.

Indians do not hinder the progress of their dead by embalming or tight coffining. When the spirit has gone they give the body back to the earth. The earth welcomes the body—coaxes new life and beauty from it, hurries over what men shudder at. Lovely tender herbage bursts from the graves, swiftly, exulting over corruption.

Opening the gate I entered and walked among the graves. Pushing aside the wild roses, bramble blossoms and scarlet honey-suckle which hugged the crude wooden crosses, I read the lettering on them—

SACRED OF KATIE—IPOO

SAM BOYAN HE DIDE—IPOO

RIP JULIE YECTON—IPOO

JOSEPH'S ROSIE DI—IPOO

Even these scant words were an innovation — white men's ways—in the old days totem signs would have told you who lay there. The Indian tongue had no written words. In place of the crosses the things belonging to the dead would have been heaped on the grave: all his dear treasures, clothes, pots and pans, bracelets —so that everyone might see what life had given to him in things of his own.

"IPOO" was common to almost every grave. I wrote the four-lettered word on a piece of paper and took it to a woman in the village.

"What does this mean? It is on the graves."

"Mean die time."

"Die time?"

"Uh huh. Tell when he die."

"But all the graves 'tell' the same."

"Uh huh. Four this kind" (she pointed separately to each of the four letters, IPOO) "tell now time."

"But everybody did not die at the same time. Some died long ago and some die now?"

"Uh huh. Maybe some year just one man die — one baby. Maybe influenza come—he come two time—one time long far, one time close. He make lots, lots Injun die."

"But, if it means the time people died, why do they put 'IPOO' on the old graves as well as on the new?"

Difficult English thoughts furrowed her still forehead. Hard English words came from her slow tongue in abrupt jerks. Her brown finger touched the I and the P. "He know," she said, "he tell it. This one and this one" (pointing to the two O's) "—small—he no matter. He change every year. Just this one and this matter" (pointing again to I and P). "He tell it."

Time was marked by centuries in this cemetery. Years—little years—what are they? As insignificant as the fact that reversing the figure nine turns it into the letter P.

❃ KITWANCOOL ❃

WHEN THE INDIANS told me about the Kitwancool totem poles, I said:

"How can I get to Kitwancool?"

"Dunno," the Indians replied.

White men told me about the Kitwancool poles too, but when I told them I wanted to go there, they advised me—"Keep out." But the thought of those old Kitwancool poles pulled at me. I was at Kitwangak, twenty or so miles from Kitwancool.

Then a halfbreed at Kitwangak said to me, "The young son of the Kitwancool chief is going in tomorrow with a load of lumber. I asked if he would take you; he will."

"How can I get out again?"

"The boy is coming back to Kitwangak after two days."

The chief's son Aleck was shy, but he spoke good English. He said I was to be at the Hudson's Bay store at eight the next morning.

I bought enough food and mosquito oil to last me two days; then I sat in front of the Hudson's Bay store from eight to eleven o'clock, waiting. I saw Aleck drive past to load his lumber. The wagon had four wheels and a long pole. He tied the lumber to the pole and a sack of oats to the lumber; I was to sit on the oats.

Rigged up in front somehow was a place for the driver—no real seat, just a couple of coal-oil boxes bound to some boards. Three men sat on the two boxes. The road was terrible. When we bumped, the man on the down-side of the boxes fell off.

A sturdy old man trudged behind the wagon. Sometimes he rode a bit on the end of the long pole, which tossed him up and down like a see-saw. The old man carried a gun and walked most of the way.

The noon sun burnt fiercely on our heads. The oat-sack gave no support to my back, and my feet dangled. I had to clutch the corner of the oat-sack with one hand to keep from falling off— with the other I held my small griffon dog. Every minute I thought we would be pitched off the pole. You could seldom see the old man because of clouds of yellow dust rolling behind the wagon. The scrub growth at the road-side smelt red hot.

The scraggy ponies dragged their feet heavily; sweat cut rivers through the dust that was caked on their sides.

One of the three men on the front seat of the wagon seemed to be a hero. The other men questioned him all the way, though generally Indians do not talk as they travel. When one of the men fell off the seat he ran round the wagon to the high side and jumped up again and all the while he did not stop asking the hero questions. There were so many holes in the road and the men fell off so often that they were always changing places, like birds on a roost in cold weather.

Suddenly we gave such an enormous bump that we all fell off together, and the horses stopped. When the wheels were not rattling any more we could hear water running. Then the old man came out of the clouds of dust behind us and said there was a stream close by.

We threw ourselves onto our stomachs, put our lips to the water and drank like horses. The Indians took the bits out of their horses' mouths and gave them food. Then the men crawled under the wagon to eat their lunch in its shade; I sat by the shadiest wheel. It was splendid to put my legs straight out and have the earth support them and the wheel support my back. The old man went to sleep.

After he woke and after the horses had pulled the wagon out of the big hole, we rumbled on again.

When the sun began to go down we were in woods, and the clouds of mosquitoes were as thick as the clouds of dust, but more painful. We let them eat us because, after bumping for seven hours, we were too tired to fight.

At last we came to a great dip where the road wound around the edge of a ravine shaped like an oblong bowl. There were trees growing in this earth bowl. It seemed to be bottomless. We were level with the tree-tops as we looked down. The road was narrow— its edges broken.

I was afraid and said, "I want to walk."

Aleck waved his hand across the ravine. "Kitwancool," he said and I saw some grey roofs on the far side of the hollow. After we had circled the ravine and climbed the road on the other side we would be there, unless we were lying dead in that deep bowl.

I said again, "I want to walk."

"Village dogs will kill you and the little dog," said Aleck. But I did walk around the bend and up the hill, until the village was near. Then I rode into Kitwancool on the oat-sack.

The dogs rushed out in a pack. The village people came out too. They made a fuss over the hero-man, clustering about him and jabbering. They paid no more attention to me than to the oat-sack.

All of them went into the nearest house taking Aleck, the hero, the old man and the other man with them, and shut the door.

I wanted to cry, sticking alone up there on top of the oats and lumber, the sagging horses in front and the yapping dogs all round, nobody to ask about anything—and very tired. Aleck had told me I could sleep on the verandah of his father's house, because I only had a cot and a tent-fly with me, and bears came into the village often at night. But how did I know which was his father's house? The dogs would tear me if I got down and there was no one to ask, anyway.

Suddenly something at the other end of the village attracted the dogs. The pack tore off and the dust hid me from them.

Aleck came out of the house and said, "We are going to have dinner in this house now." Then he went in again and shut the door.

THE WAGON WAS standing in the new part of the village. Below us, on the right, I could see a row of old houses. They were dim, for the light was going, but above them, black and clear against the sky stood the old totem poles of Kitwancool. I jumped down from the wagon and came to them. That part of the village was quite dead. Between the river and the poles was a flat of green grass. Above, stood the houses, grey and broken. They were in a long, wavering row, with wide, windowless fronts. The totem poles stood before them there on the top of a little bank above the green flat. There were a few poles down on the flat too, and some graves that had fences round them and roofs over the tops.

When it was almost dark I went back to the wagon.

THE HOUSE OF Aleck's father was the last one at the other end of the new village. It was one great room like a hall, and was built of new

logs. It had seven windows and two doors; all the windows were propped open with blue castor-oil bottles.

I was surprised to find that the old man who had trudged behind our wagon was Chief Douse—Aleck's father.

Mrs. Douse was more important than Mr. Douse; she was a chieftainess in her own right, and had great dignity. Neither of them spoke to me that night. Aleck showed me where to put my bed on the verandah and I hung the fly over it. I ate a dry scrap of food and turned into my blankets. I had no netting, and the mosquitoes tormented me.

My heart said into the thick dark, "Why did I come?"

And the dark answered, "You know."

IN THE MORNING the hero-man came to me and said, "My mother-in-law wishes to speak with you. She does not know English words so she will talk through my tongue."

I stood before the tall, cold woman. She folded her arms across her body and her eyes searched my face. They were as expressive as if she were saying the words herself instead of using the hero's tongue.

"My mother-in-law wishes to know why you have come to our village."

"I want to make some pictures of the totem poles."

"What do you want our totem poles for?"

"Because they are beautiful. They are getting old now, and your people make very few new ones. The young people do not value the poles as the old ones did. By and by there will be no more poles. I want to make pictures of them, so that your young people as well as the white people will see how fine your totem poles used to be."

Mrs. Douse listened when the young man told her this. Her eyes raked my face to see if I was talking "straight". Then she waved her hand towards the village.

"Go along," she said through the interpeter, "and I shall see." She was neither friendly nor angry. Perhaps I was going to be turned out of this place that had been so difficult to get into.

The air was hot and heavy. I turned towards the old village with the pup Ginger Pop at my heels. Suddenly there was a roar of yelpings, and I saw my little dog putting half a dozen big ones to rout down the village street. Their tails were flat, their tongues lolled and they yelped. The Douses all rushed out of their house to see what the noise was about, and we laughed together so hard that the strain, which before had been between us, broke.

THE SUN ENRICHED the old poles grandly. They were carved elaborately and with great sincerity. Several times the figure of a woman that held a child was represented. The babies had faces like wise little old men. The mothers expressed all womanhood— the big wooden hands holding the child were so full of tenderness they had to be distorted enormously in order to contain it all. Womanhood was strong in Kitwancool. Perhaps, after all, Mrs. Douse might let me stay.

I sat in front of a totem mother and began to draw—so full of her strange, wild beauty that I did not notice the storm that was coming, till the totem poles went black, flashed vividly white and then went black again. Bang upon bang, came the claps of thunder. The hills on one side tossed it to the hills on the other; sheets of rain washed over me. I was beside a grave down on the green flat; some of the pickets of its fence were gone, so I crawled through onto the grave with Ginger Pop in my arms to shelter under its roof. Stinging

nettles grew on top of the grave with mosquitoes hiding under their leaves. While I was beating down the nettles with my easel, it struck the head of a big wooden bear squatted on the grave. He startled me. He was painted red. As I sat down upon him my foot hit something that made a hollow rattling noise. It was a shaman's rattle. This then must be a shaman's, a medicine-man's grave, and this the rattle he had used to scare away evil spirits. Shamen worked black magic. His body lay here just a few feet below me in the earth. At the thought I made a dash for the broken community house on the bank above. All the Indian horses had got there first and taken for their shelter the only corner of the house that had any roof over it.

I put my stool near the wall and sat upon it. The water ran down the wall in rivers. The dog shivered under my coat—both of us were wet to the skin. My sketch sack was so full of water that when I emptied it onto the ground it made the pool we sat in bigger.

After two hours the rain stopped suddenly. The horses held their bones stiff and quivered their skins. It made the rain fly out of their coats and splash me. One by one they trooped out through a hole in the wall. When their hooves struck the baseboard there was a sodden thud. Ginger Pop shook himself too, but I could only drip. Water poured from the eyes of the totems and from the tips of their carved noses. New little rivers trickled across the green flat. The big river was whipped to froth. A blur like boiling mist hung over it.

WHEN I GOT back to the new village I found my bed and things in a corner of the Douses' great room. The hero told me, "My mother-in-law says you may live in her house. Here is a rocking-chair for you."

Mrs. Douse acknowledged my gratitude stolidly. I gave Mr. Douse a dollar and asked if I might have a big fire to dry my things

and make tea. There were two stoves—the one at their end of the room was alight. Soon, mine too was roaring and it was cosy. When the Indians accepted me as one of themselves, I was very grateful.

THE PEOPLE WHO lived in that big room of the Douses were two married daughters, their husbands and children, the son Aleck and an orphan girl called Lizzie. The old couple came and went continually, but they ate and slept in a shanty at the back of the new house. This little place had been made round them. The floor was of earth and the walls were of cedar. The fire on the ground sent its smoke through a smoke-hole in the roof. Dried salmon hung on racks. The old people's mattress was on the floor. The place was full of themselves—they had breathed themselves into it as a bird, with its head under its wing, breathes itself into its own cosiness. The Douses were glad for their children to have the big fine house and be modern but this was the right sort of place for themselves.

Life in the big house was most interesting. A baby swung in its cradle from the rafters; everyone tossed the cradle as he passed and the baby cooed and gurgled. There was a crippled child of six—pinched and white under her brown skin; she sat in a chair all day. And there was Orphan Lizzie who would slip out into the wet bushes and come back with a wild strawberry or a flower in her grubby little hand, and, kneeling by the sick child's chair, would open her fingers suddenly on the surprise.

There was no rush, no scolding, no roughness in this household. When anyone was sleepy he slept; when they were hungry they ate; if they were sorry they cried, and if they were glad they sang. They enjoyed Ginger Pop's fiery temper, the tilt of his nose and particularly the way he kept the house free of Indian dogs. It was Ginger who bridged the gap between their language and

mine with laughter. Ginger's snore was the only sound in that great room at night. Indians sleep quietly.

ORPHAN LIZZIE WAS shy as a rabbit but completely unselfconscious. It was she who set the food on the big table and cleared away the dishes. There did not seem to be any particular meal-times. Lizzie always took a long lick at the top of the jam-tin as she passed it.

The first morning I woke at the Douses', I went very early to wash myself in the creek below the house. I was kneeling on the stones brushing my teeth. It was very cold. Suddenly I looked up— Lizzie was close by me, watching. When I looked up, she darted away like a fawn, leaving her water pails behind. Later, Mrs. Douse came to my corner of the house, carrying a tin basin; behind her was Lizzie with a tiny glass cream pitcher full of water, and behind Lizzie was the hero.

"My mother-in-law says the river is too cold for you to wash in. Here is water and a basin for you."

Everyone watched my washing next morning. The washing of my ears interested them most.

ONE DAY AFTER work I found the Douse family all sitting round on the floor. In the centre of the group was Lizzie. She was beating something in a pail, beating it with her hands; her arms were blobbed with pink froth to the elbows. Everyone stuck his hand into Lizzie's pail and hooked out some of the froth in the crook of his fingers, then took long delicious licks. They invited me to lick too. It was "soperlallie", or soap berry. It grows in the woods; when you beat the berry it froths up and has a queer bitter taste. The Indians love it.

FOR TWO DAYS from dawn till dark I worked down in the old part of the village. On the third day Aleck was to take me back to Kitwangak. But that night it started to rain. It rained for three days and three nights without stopping; the road was impossible. I had only provisioned for two days, had been here five and had given all the best bits from my box to the sick child. All the food I had left for the last three days was hard tack and raisins. I drank hot water, and rocked my hunger to the tune of the rain beating on the window. Ginger Pop munched hard tack unconcerned — amusing everybody.

The Indians would have shared the loaf and jam-tin with me, but I did not tell them that I had no food. The thought of Lizzie's tongue licking the jam-tin stopped me.

When it rained, the Indians drowsed like flies, heavy as the day itself.

ON THE SIXTH day of my stay in Kitwancool the sun shone again, but we had to wait a bit for the puddles to drain.

I straightened out my obligations and said goodbye to Mr. and Mrs. Douse. The light wagon that was taking me out seemed luxurious after the thing I had come in on. I climbed up beside Aleck. He gathered his reins and "giddapped".

Mrs. Douse, followed by her husband, came out of the house and waved a halt. She spoke to Aleck.

"My mother wants to see your pictures."

"But I showed her every one before they were packed."

At the time I had thought her stolidly indifferent.

"My mother wishes to see the pictures again."

I clambered over the back of the wagon, unpacked the wet canvases and opened the sketchbooks. She went through them all.

The two best poles in the village belonged to Mrs. Douse. She argued and discussed with her husband. I told Aleck to ask if his mother would like to have me give her pictures of her poles. If so, I would send them through the Hudson's Bay store at Kitwangak. Mrs. Douse's neck loosened. Her head nodded violently and I saw her smile for the first time.

Repacking, I climbed over the back of the seat to Aleck.

"Giddap!"

The reins flapped: we were off. The dust was laid; everything was keen and fresh; indeed the appetites of the mosquitoes were very keen.

WHEN I GOT back to Kitwangak the Mounted Police came to see me.

"You have been in to Kitwancool?"

"Yes."

"How did the Indians treat you?"

"Splendidly."

"Learned their lesson, eh?" said the man. "We have had no end of trouble with those people—chased missionaries out and drove surveyors off with axes—simply won't have whites in their village. I would never have advised anyone going in—particularly a woman. No, I would certainly have said, 'Keep out.'"

"Then I am glad I did not ask for your advice," I said, "perhaps it is because I am a woman that they were so good to me."

"One of the men who went in on the wagon with you was straight from jail, a fierce, troublesome customer."

NOW I KNEW who the hero was.

❈ CANOE ❈

THREE RED BULLS—sluggish bestial creatures with white faces and morose bloodshot eyes—and the missionaries, made me long to get away from the village. But I could not: there was no boat.

I knew the roof and the ricketiness of every Indian woodshed. This was the steepest roof of them all, and I was panting a bit. It is not easy to climb with a little dog in one hand and the hot breath of three bulls close behind you. Those three detestable white faces were clustered round my canvas below. They were giving terrible bellows and hoofing up the sand.

Far across the water there appeared a tiny speck: it grew and grew. By the time the bulls had decided to move on, it was a sizable canoe heading for the mudflats beyond the beach. The tide was very far out. When the canoe grounded down there on the mud, an Indian family swarmed over her side, and began plodding heavily across the sucking ooze towards an Indian hut above the beach. I met them where the sand and the mud joined.

"Are you going back to Alliford? Will you take me?"

"Uh huh," they were; "Uh huh," they would.

"How soon?"

"Plitty-big-hully-up-quick."

I ran up the hill to the mission house. Lunch was ready but I did not wait. I packed my things in a hurry and ran down the hill to the Indian hut, and sat myself on a beach log where I could watch the Indians' movements.

The Indians gathered raspberries from a poor little patch at the back of the house. They borrowed a huge preserving kettle from the farthest house in the village. Grandpa fetched it; his locomotion was very slow. The women took pails to the village tap, lit a fire, heated water; washed clothes—hung out—gathered in; set dough, made bread, baked bread; boiled jam, bottled jam; cooked meals and ate meals. Grandpa and the baby took sleeps on the kitchen floor, while I sat and sat on my log with my little dog in my lap, waiting. When the bulls came down our way I ran, clutching the dog. When the bulls had passed, we sat down again. But even when I was running, I watched the canoe. Sometimes I went to the door and asked,

"When do we go?"

"Bymby," or "Plitty soon," they said.

I suggested going up to the mission house to get something to eat, but they shook their heads violently, made the motion of swift running in the direction of the canoe and said, "Big-hully-up-quick."

I found a ship's biscuit and a wizened apple in my sketch sack. They smelled of turpentine and revolted my appetite. At dusk I ate them greedily.

It did not get dark. The sun and the moon crossed ways before day ended. By and by the bulls nodded up the hill and sat in front of the mission gate to spend the night. In the house the Indians lit a coal-oil lamp. The tide brought the canoe in. She floated there before me.

At nine o'clock everything was ready. The Indians waded back and forth stowing the jam, the hot bread, the wash, and sundry bundles in the canoe. They beckoned to me. As I waded out, the water was icy against my naked feet. I was given the bow seat, a small round stick like a hen roost. I sat down on the floor and rested my back against the roost, holding the small dog in my lap. Behind me in the point of the canoe were two Indian dogs, which kept thrusting mangy muzzles under my arms, sniffing at my griffon dog.

Grandpa took one oar, the small boy of six the other. The mother in the stern held a sleeping child under her shawl and grasped the steering paddle. A young girl beside her settled into a shawl-swathed lump. Children tumbled themselves among the household goods and immediately slept.

Loosed from her mooring, the big canoe glided forward. The man and the boy rowed her into the current. When she met it she swerved like a frightened horse—accepted—gave herself to its guiding, her wolf's head stuck proud and high above the water.

The child-rower tipped forward in sleep and rolled among the bundles. The old man, shipping the child's oar and his own, slumped down among the jam, loaves and washing, resting his bent old back against the thwart.

The canoe passed shores crammed with trees—trees over-hanging stony beaches, trees held back by rocky cliffs, pointed fir trees climbing in dark masses up the mountain sides, moon-light silvering their blackness.

Our going was imperceptible, the woman's steering paddle the only thing that moved, its silent cuts stirring phosphorus like white fire.

Time and texture faded... ceased to exist... day was gone, yet it was not night. Water was not wet nor deep, just smoothness spread with light.

As the canoe glided on, her human cargo was as silent as the cedar-life that once had filled her. She had done with the forest now; when they shoved her into the sea they had dug out her heart. Submissively she accepted the new element, going with the tide. When tide or wind crossed her she became fractious. Some still element of the forest clung yet to the cedar's hollow rind which resented the restless push of waves.

Once only during the whole trip were words exchanged in the canoe. The old man, turning to me, said,

"Where you come from?"

"Victoria."

"Victorlia? Victorlia good place—still. Vancouver, Seattle, lots, lots trouble. Victorlia plenty still."

It was midnight when the wolf-like nose of our canoe nuzzled up to the landing at Alliford. All the village was dark. Our little group was silhouetted on the landing for one moment while silver passed from my hand to the Indian's.

"Good-night."

"Gu-ni'."

One solitary speck and a huddle of specks moved across the beach, crossed the edge of visibility and plunged into immense night.

Slowly the canoe drifted away from the moonlit landing, till, at the end of her rope, she lay an empty thing, floating among the shadows of an inverted forest.